Victorian
Trinket Boxes

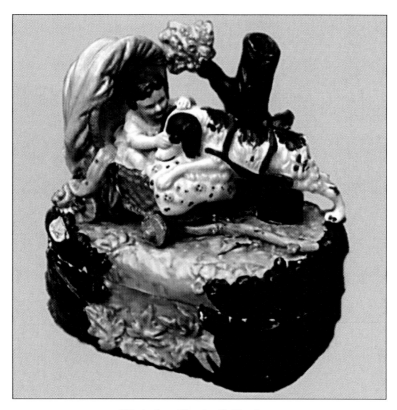

Plate 1: **Conta & Boehme**

Child in covered wagon with dog.
1860-1880
Unmarked
(Group D)

Courtesy of
Mr. Freyer, Assistant Director
Leuchtenburg Museum, Germany

CONTENTS

Dedication

This book is dedicated to Sigrid Enkelmann who passed away prior to its publication.

Her friendship and personal warmth will never be forgotten.

Acknowledgement

As avid devotees of trinket boxes for several years, we were dismayed with the lack of written information available to the collector. Published books and articles are confusing in that conflicting terms and statements often appear from one article to another.

Our goals in this book are to introduce the new collector to the fascinating world of trinket boxes, and to expand the knowledge of the current collector with accurate information.

We wish to thank the following people for their assistance in providing research material, photographs, porcelain boxes, and continual help and support in the writing of this book.

Karen Fokken for her German translation
Kay Wright, copy editor

To Suzanne and Edwin Meyer of Connecticut. From Florida: Carl Cotton, Patricia France of Victoria's Parlour Antiques in Belleair Bluffs, and to Bess & Edward Le Zotte for volunteering their porcelain boxes to be photographed.

Frank Flynn of Frank Flynn Studio in Ocala, Florida for his unending patience in teaching me how to photograph these porcelain boxes. "Thank you Frank."

We owe a personal debt of gratitude to Hans Walter Enkelmann, Germany, for his dedication and hard work in researching, excavating, and photographing items and material for this book. We also thank him and his family, Thomas and Uta, for their hospitality during our stay with them in Germany.

Collecting **Victorian Trinket Boxes** is a rewarding experience and we welcome aspiring collectors to join us in our search.

For the serious collector, certain guidelines rule each purchase.

Desirability and rarity always affect prices. If the theme or design of a box is in great demand, you will pay a premium for it.

Condition is a major factor. Boxes in mint condition with their original gold and paint command the highest prices.

Areas to consider are missing parts; obvious repairs; chips; cracks; and repaints. Usually missing mirrors do not affect a box's value. Some people have them replaced while others find them attractive without mirrors. Repaired boxes should be sold "as is" and reputable dealers will point out the repair, if asked. Don't be put off by mold cracks or mold defects! These occurred during the manufacturing process and don't negate the box value. Beware of repaints! Some have been redone so much that they look like a reproduction or they are concealing a serious repair. We recommend examining the item you wish to purchase very carefully under good lighting. With the growing number of porcelain restorers, one must be careful. A good restoration may not bother you, but remember, the price should reflect the work.

Price is definitely an important consideration. Your goals and your budget sometimes conflict, but it is safe to say that additional money spent on a mint box is better than a like amount put towards two damaged pieces. With time, patience, and knowledge, you can purchase a mint cover or base separately and try to match them. This is an economical way to add a few pieces to your collection, but time constraints limit substantial additions using this method. One must also know exactly what style base goes with a particular style top. Just any top and bottom will not do. Even then, the cover may not fit as it should (see page 33, 1st paragraph). We have seen many trinket boxes in shops and shows where the top and bottom were not mates, yet the dealers were asking mint prices.

Size and theme are excellent concentration areas. Miniature, vintage, and bureau or dresser sizes are the most common types while figurals, animals, baskets, hands, and furniture forms are popular, specialized themes.

When you find a box of interest, examine it carefully and don't hesitate to talk with the dealer about it. You may learn some new facts or hear old myths, but all of it is interesting.

We have purchased several excellent boxes by being placed on a want list with several dealers. Give the dealer your desired price range so your needs can be properly searched.

Our Price Guide is directed towards the Buyer rather than the Seller. Values were researched through antique shows, auctions, dealer shops, and individual sales between collectors throughout the United States.

Surprisingly, regional pricing does not vary significantly. Rather, the previous factors cited determine the prices.

Please remember, it's just a guide. Keep in mind - there are only two kinds of boxes: MINT and OTHER. Prices should reflect this difference.

PRICE GUIDE	GROUP
$ 35.00 — $ 75.00	A
$ 75.00 — $150.00	B
$150.00 — $225.00	C
$225.00 — $300.00	D
$300.00 +	E

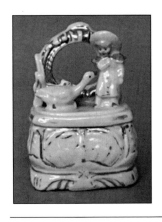

Plate 2

MINIATURE: Boy and goose.
2-3/4" tall.
Conta shield and model number
79 impressed on cover.
(Group B)

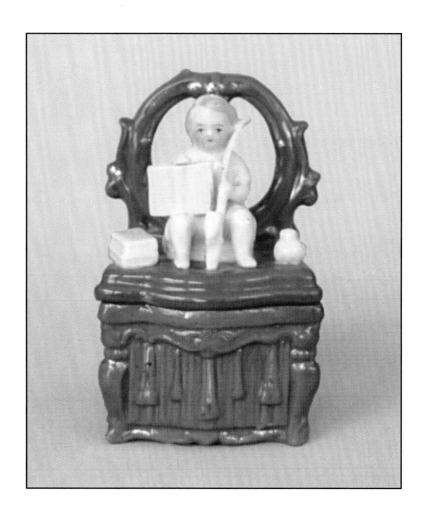

Plate 3: **Conta & Boehme**

Child sitting holding a long-handled pipe and book. Two books and a jar on ground. Conta shield, model number 3574, and the letter **P** are impressed on cover. This box normally comes in white porcelain, and is seldom found in the green porcelain. (Group D)

CHAPTER I

The Trinket Box

*Y*ou enter the show hall and within a few steps your eyes fix upon a small porcelain box nestled among some china and glass figurines.

The box is in two parts with animals, children, musical instruments, etc. adorning the cover. A quick inspection of the item shows a coat of arms depicting a shield with upraised arm and sword.

You have discovered a Conta & Boehme trinket box from Possneck, Germany.

Meanwhile, as you admire your find, the exhibitor extolls the virtue of the "Staffordshire" item in your hands. "Don't worry about the slight crack or broken fence post as everything that old has something wrong with it."

Welcome to the world of trinket box collecting.

This fascinating hobby will result in many new friendships, several unusual pieces, and various box stories, mostly myths.

Although a few articles have been written on the subject of trinket boxes, those in print are very confusing. Some say they are little boxes made of hard-paste porcelain; others claim they are made of soft-paste porcelain. They have been called trinket boxes, fairings, patch boxes, pin boxes, Staffordshire boxes, and Victorian boxes. They are said to originate from England, Austria, the Netherlands, Switzerland, Germany, and France. Some claim they were given away as prizes at fairs, sold at many seaside resorts as souvenirs, given to children for gifts at birthdays and Christmas time, and presented to young girls by their sweethearts.

Regardless of their origin, these boxes are now in great demand.

As long-time collectors of trinket boxes, the conflict over various printed facts concerned us. Although little is known about these charming boxes, we have compiled some information which we hope will be helpful to you and add to your enjoyment of these collectibles.

The majority of the boxes bear the impressed or raised mark of an enclosed shield and an arm holding a sword. This mark appears on the bottom of the base or the underside of the cover. Many times the model and painters number are shown as well.

This mark belongs to a company called Conta & Boehme of Possneck, Germany and should not be confused with that of Springer & Company of Elbogen (now Loket in Czechoslovakia). Both marks are pictured below for your reference.

This book concentrates mainly on the hard-paste porcelain trinket boxes manufactured by Conta & Boehme, but does contain many unmarked and unidentified boxes. The majority of these boxes were imported into the United States prior to the American McKinley Taft Act of 1891. This legislation, better known as the "Country of Origin" law, states all wares imported into the United States had to have the country of origin clearly marked.

Some unmarked boxes can often be identified by comparing their shape, style, and molded items to known Conta & Boehme pieces. We hope this book will help in identifying many boxes for you.

Many of the unmarked boxes did indeed originate from countries such as England, Austria, France, and the Netherlands as well as from other German factories. Although most manufacturers failed to mark all their pieces, we have pictured several different marked boxes found.

Pictured below is a lightweight, bisque box trimmed in gold. On the base, in blue overglaze, are crossed arrows with four feathers on each arrow. This mark is often credited to the Kalk Porcelain Factory located in Eisenberg, Germany. However, all the known Kalk marks show crossed arrows with only three feathers on each arrow, not four.

We have seen this four-feathered crossed arrow mark along with a paper label on porcelain pieces from Japan. This company, called Original Arnart Creations, was one of the largest reproducers of porcelain manufactured by other companies. They reproduced many Conta & Boehme items from figurines, toothpicks, matchstrikers, boxes, etc. Fortunately, they marked many of their reproductions with the crossed arrows.

On the back panel of this box are four buttons. Each button is labeled in German: **Mama!** (Mother!), **Milch!** (Milk!), **Bin Nass!** (Have Wet!), and **Vorsingen!** (Sing!). The baby is pushing the third button to let someone know it has wet its diaper. Written on the blanket at the foot of the child's basket are the words **Unsre Modernes Baby** (Our Modern Baby). This box can be found with or without the back panel and was definitely made after 1900.

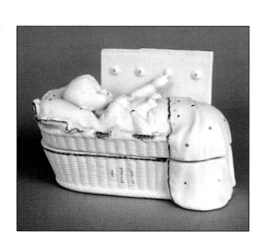

Arnart mark

Kalk mark

Plate 4 (Group B)

Two German boxes with the initials **SPM** impressed on the underside of the cover. (We have found two companies which used these initials: Schmeisser Porcelain of Eisenberg and Buckau Porcelain of Prussia, but neither match the mark.) These boxes closely resemble Conta & Boehme pieces. Maker unknown.

 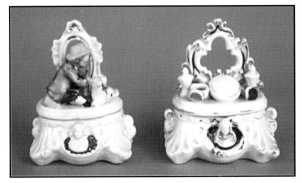

Plate 5: a b
(Group B)

a. Boy feeding carrot to lamb
b. Pocket watch, two rings, seal stamp, and two covered jars.

This large French box with a small child sitting in an over-sized top hat, is made of soft-paste porcelain. On the base is an impressed eagle, the number 251, and what appears to be a champagne glass with the letter **A** coming out of it. Maker unknown.

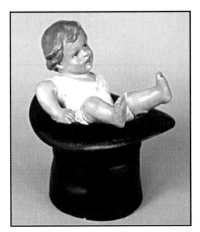

Plate 6 (Group C)

A German box with the letters **EBS** and number 743 impressed along with an anchor stamped in blue underglaze. This mark belongs to the company called Ernst Bohne Sobne of Rudolstadt (Ernest Bohne & Son) which was founded by Bernhard Bohne and Martha Suhr in 1854. It was one of Conta & Boehme's largest competitors in all types of porcelain items.

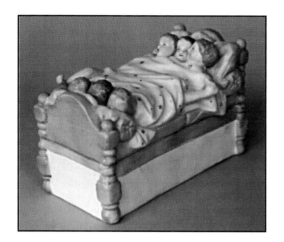

Six children in bed. The child on each edge of the bed has his/her foot sticking outside of the covers. Dated approximately 1870's or 1880's. Unglazed. (Courtesy of Bess & Edward Le Zotte)

Plate 7 (Group C)

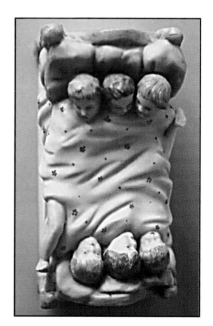

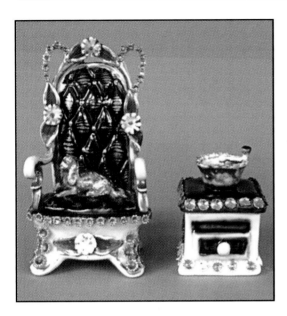

Plate 8: a b
Maker unknown

These two boxes decorated with gold rosettes and painted in cobalt blue were manufactured by the same company. The letter **R** is impressed on the base of both. This mark could possibly belong to the Volkstedt Porcelain Company in Rudolstadt, Germany. They used such a mark during the 19th century.

a) Cushion in chair the dog is sitting on lifts off for the cover. (Group B)

b) Coffee grinder. (Group A)

Plate 9
(Reproduction)

This box is stamped in red "JAPAN" on the base. It is definitely a copy of a Conta & Boehme box. It is quite large measuring 4-1/2" wide, 3-1/4" deep, and 3-3/4" tall. (Group A)

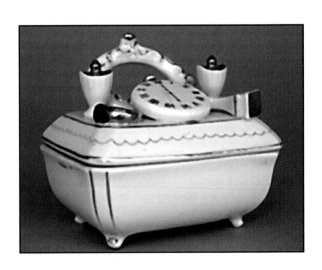

As our love of trinket boxes began and continues with Conta & Boehme, our research on other factories is somewhat limited.

The German District of Thuringer (once known as Saxony), was a large manufacturing center for porcelain production. It started during the middle of the 19th century when many small factories began producing, what was considered at that time, cheap, decorative porcelain. They had discovered how to inexpensively apply bright colors and gold that would be capable of withstanding high curing temperature ranges. This allowed them to produce high quality boxes at much lower prices than other areas. England encouraged the factories by not charging any import duties on the German boxes; therefore, a large quantity could be mass produced for export.

A hard-paste porcelain material was used as soft-paste porcelain was seldom found in Germany. The early pieces were made of a heavy white paste, much heavier than later examples.

An examination of many pieces concludes that the factories borrowed freely from each others designs. Exact duplicates are rare, although item pairs are frequently found. Automation was unknown so differences in figure placement, modeling, or coloring existed.

The boxes definitely are not Staffordshire as they are sometimes called. The most logical reason for this mis-labeling is due to the fact that during the 1920's and 1930's, German wares were not favored. Products from England; however, were very popular, especially the items from the Staffordshire district. As the boxes needed a more appealing description, the term "Staffordshire" was substituted. This name was acceptable for the times. They have now become known and accepted as German boxes. Many lovely boxes did indeed come from the District of Staffordshire in England, but they should not be confused with those from Germany.

Patch box, as they are sometimes called, is another inaccurate name for them. Patches, tiny pieces of black silk, or court plaster, worn by the ladies of the period to hide a blemish or to heighten their beauty, were kept in tiny boxes. The boxes called *"boite a mouches"* by the French, were popular during the reign of Louis XIV (1643-1715) when peruke (periwigs) for the gentle-

men and elaborate coiffures for the ladies were in style. By the late 1600's, they were given the name "patch boxes" by the English. Trinket boxes came into popularity long after patches ceased to be worn as fashionable dress.

The term pin boxes has also been used and is still heard today. Pins in England were very hard to come by. When the pins were purchased, a special container was needed to store them safely. As the boxes had a number of uses, it is not unlikely that some ladies stored pins in them.

Some boxes could be considered fairings. Fairings, as the name implies, were gifts bought or won at a village fair. Could it be that fairing is a shortened version of "fair earning" for a skill well done? Imagine going to your county fair and playing ring toss, baseball throw, or other games of chance. Today the fruit of your success is a stuffed toy, plastic whatsit, or perhaps a t-shirt emblazoned with the current hot rock group faces. Years ago, your prize would have been a porcelain object with characters or scenery perhaps bearing an inscription.

We prefer to call them *"Victorian Trinket Boxes."* The Victorian era (1837—1901) was the reigning period of Queen Victoria of England. The majority of the trinket boxes were made during this time span when it was in vogue to have knickknack items on shelves, tables, mantels, and holders of all sorts. The word "trinket," according to Webster's Dictionary, means "a small ornament such as a jewel or ring."

In the Conta & Boehme trade journal advertisement, opposite page, they were simply called **"jewelry and mirrored boxes."**

Conta & Boehme,
Porzellanfabrik u. Dampf-Gipsfabrik in Pössneck (◄ ♱ ⚓),
Sachsen-Meinigen. — T.-A.: Conta. — ⬥ Nr. 3. — Inh.: Kommer-
zienrat Max Conta, Hermann u. Robert Conta. — Bankkonten:
Reichsbank u. Deutsche Bank.
 Fabrikat in Hartporzellan: Luxus- u. Phantasie-
artikel für In- u. Ausland. — Spez. u. Export: Basar-
artikel in allen Preislagen, Kandelaber, Tafelaufsätze,
Jardinieren, Uhrenständer, Spiegel, Gruppen, Pagoden
u. sonstige Wackelfiguren, Spitzenfiguren, Figuren,
Heiligenfiguren, Weihkessel, Tiere, Tabaksdosen, Zi-
garrenständer u. -Schalen, Aschenständer, Streich-
feuerzeuge, Menuhalter, Senfmenagen, Schreibzeuge,
Schmuck- u. Spiegeldosen, Vasen, Großartikel, Badekinder, Puppen-
köpfe, Zeugpuppen, Wandreliefs, Leuchter, Jardinieren zum Hängen.
Ferner Fabrikation von feinstem Alabaster-, Modell-, Form-, Stuck-,
Bau- u. Düngegips.

Advertisement from a German trade journal of 1907 showing the Conta shield mark found on many porcelain pieces. Listed are the many different items manufactured and sold by the company.

Conta & Boehme

Porcelain and steam-plaster factory in Possneck.
The Business -- T.-A.: Conta -- No. 3. -- Proprietors: Commerce Counsel: Max Conta, Herman and Robert Conta. -- Bank Account: German National Bank and German Bank.
 Manufacturer of hard-porcelain: luxury and fantasy goods for domestic and export sale. Speciality and export: bazaar goods in all price ranges, candelabras, table center pieces, jardinieres, watch holders, mirrors, groupings, pagodas and other nodding figurines, lace figurines, religious figurines, holy water basins, animals, tobacco boxes, cigar holders and trays, ashstands, matchstrikers, menu holders, mustard cruet sets, pen and ink holders, **jewelry and mirrored boxes**, vases, large scale articles, bath dolls, doll heads, cloth dolls, wall reliefs, chandeliers, hanging jardinieres. Further production from the finest alabaster-, model-, form-, and earth-tone plasters.

(English translation)

The Conta & Boehme factory was built in the 1880's. It is still being used today by a manufacturer of lamp parts. The Conta family coat of arms is chiseled into sandstone under the roof gable on the side of the building which faces the street. (As of June, 1988, a remodeling project changed the roof-top design. The arm in the Conta shield was removed and preserved.)

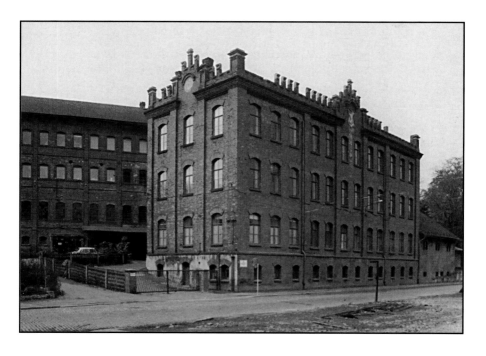

Plate 10

Conta & Boehme Factory Building

Courtesy of
Mr. Werner, Director
Thuringer Native Museum in Saalfeld, Germany

CHAPTER II

A Brief History of Conta and Boehme

In 1801, Johann Tobias Albert, who apprenticed as a porcelain painter in the famous VOLKSTEDT manufacturing company, founded his own porcelain factory. It was located in Possneck, Germany. During the early years, the factory was called the "POSSNECK Porcelain Manufacturing Company." The letter **P** (for Possneck) was used to identify their products.

In 1809, Mr. Albert purchased the GERA manufacturing company. He sold the POSSNECK factory in 1814, to Albrecht Wilhelm Ernst Conta, a local lawyer, and Christian Gottlieb Boehme, a factory employee. The new partnership was named "Conta and Boehme."

Mr. Boehme was born in 1771, in Wermsdorf, Germany. As a long-time employee at the POSSNECK factory, he had knowledge of the entire porcelain process enabling him to assume the company's technical leadership.

Mr. Conta was born in 1756, in Saalfeld, Germany. His legal training allowed him to take charge of the business aspects of the company. Unfortunately, both partners were able to enjoy the fruits of their labor for only a few short years. Mr. Conta died in 1819 at the age of 63. His wife and three sons continued to manage the business in partnership with the Boehmes. Two years later, on December 27, 1821, Mr. Boehme died at the age of 50. His heirs sold their share to the remaining Conta family in 1823. In 1837, Hermann Conta died. Three years later, April 30, 1840, Rosine Maria Conta died leaving the company to her sons, Carl and Bernard Conta.

After inheriting the company, their goal was to modernize and enlarge the factory; to change their product assortment; open

new markets; and naturally, to increase their wealth. The factory mark was changed to the Conta shield to satisfy the brothers self-esteem and sense of pride. This brand was used in the 1850's, possibly earlier. Excavated items have been found with the Conta shield mark crudely stamped in blue underglaze.

The company name was never changed; it remained Conta & Boehme until its closing. Over a period of years, the company began to grow and prosper and the Contas became one of the wealthiest and most respected families in Possneck.

At its peak, the company employed over 800 people and developed into the largest business venture in Possneck. Conta & Boehme's first products were simple wares such as pipeheads and dishes. The second half of the 19th century saw a shift from household to decorative porcelain items such as dolls, trinket boxes, knickknack items, and lavish figurines. These products were primarily made for export, with England and the United States being the major markets.

With the beginning of the 20th century came a slow but steady decline of porcelain production. World War I was a de-vasting blow for the company as Foreign Exchange collapsed. Through World War I, the company continued on a downward slope.

In 1921, the company employed only 97 workers. By 1926, company sales had seriously fallen and all mold casting and firing ceased in 1929. A nearby factory, the KONITZ porcelain factory, owned and operated by the Metzel brothers (1909—1945), contin-ued this work for two more years using molds supplied by Conta & Boehme. The porcelain painting was still carried on at Conta & Boehme by approximately 30 remaining porcelain painters, mostly elderly.

In December of 1931, the Conta family decided to stop production. With this, a 117 year-old tradition in Possneck came to an end.

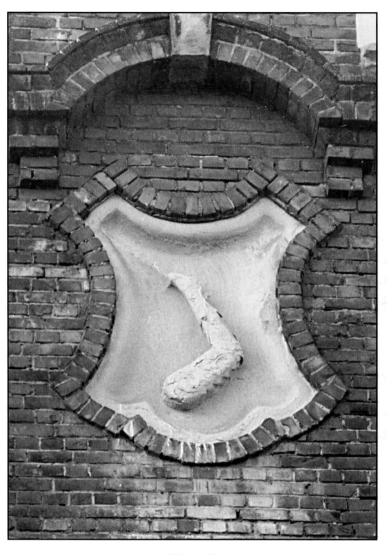

Plate 11

Close-up view of the Conta & Boehme
coat of arms under the roof gable.

Courtesy of Hans Walter Enkelmann, Germany

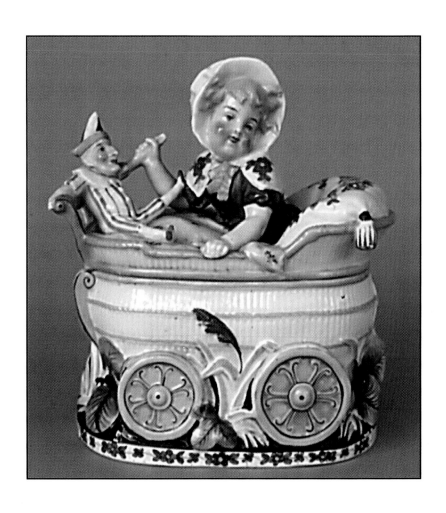

Plate 12: Conta & Boehme

Wicker carriage with girl and jester doll.
Conta shield and model number 2596 impressed on cover.
Large box. (Group E)

CHAPTER III

The Porcelain Mark

*O*ne or more numbers are located on most porcelain boxes of Conta & Boehme, either on the base or on the underside of the cover. These numbers consist of a one- to four-digit article or model number, a two- to three-digit unidentified number, a roman numeral size number, and a one- to three-digit painters number. Rather than using their initials, each painter was assigned a special number to use.

1840 to 1845: Items from this period are very heavy with little gold and very little paint (only one color, if any, was used). No model numbers.

1845 to 1850: As production drastically increased, it became obvious that a numbering system must be used. The porcelain items are still heavy with a bit more gold and begin to appear more colorfully painted. The article numbers are roughly incised. Occasionally, the article number is also underlined or encircled (dotted lines inscribed around it). The oldest of these article numbers were inscribed into the clay model. They were transferred in this manner to the plaster molds and appeared in the same fashion on each porcelain piece. The article numbers were incised into the plaster mold in exceptional cases. The numbers then appear raised on the porcelain piece. The numbers had to be

Plate 13

scratched in mirrored image. If this procedure was not followed, the number appeared on the porcelain item in reverse image. A size number also began within this time period. The item's size was indicated by roman numerals scratched into the porcelain material or transferred through the plaster mold. In most cases (but not all), the largest design corresponded with the largest number, the smallest design corresponded with the smallest number.

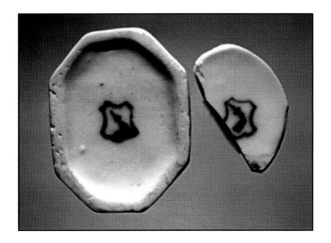

Plate 14

These excavated pieces may have been from the very beginning of the experimental stages using the Conta shield mark, possibly as early as 1840's. The ink stamp, in blue underglaze, is very thick and crude.

1850 to 1891: As time went on, the etched article numbers became less clear and finally illegible through frequent use of the clay model and the plaster molds. A different technique was then employed. The article number was pressed into the soft mass with a metal stamp before firing. Articles produced over several years may show both the old and the new number system. The Conta shield mark was also impressed in the same fashion or a seal mark (raised or molded in relief) was applied. This period also includes the painter's number painted in the same predominant color as the

item itself. The letter **P** was sparingly used as well. A one- to three-digit unknown number can also be found during this time frame. Unfortunately, not all items were marked. We have heard many times from dealers that because an item is not marked, it is much older. To quote: "The older items were never marked." True in a sense. Older items were not marked, but that does not apply to all unmarked porcelain. Approximately 20% of Conta and Boehme porcelain was marked. You can find two identical trinket boxes where one will be marked and the other unmarked, yet both pieces are of the same era.

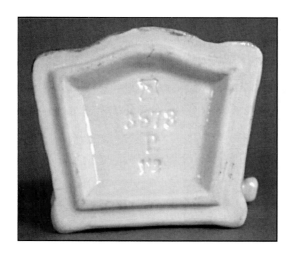

Plate 15

Impressed with the Conta shield, model number 3573, the letter **P**, and number 112.

Plate 16

Raised Conta shield, model number 3572, and number 110.

1891 to 1931: Starting in 1891, all wares shipped into the U.S. had to be clearly marked with the country of origin. This was done either with an ink stamp or paper label. To this date, we have found only one box with the Conta shield mark done in an ink stamp (blue underglaze, no paper label). They also used a stamp "Made in Germany." Porcelain items have been found with both the impressed Conta shield mark and the "Made in Germany" ink stamp. These were definitely manufactured after 1891 (or made prior to 1891, but not sold until after 1891 and the ink stamp added). The exact date Conta & Boehme stopped making the boxes is unknown.

Plate 17

Two children sitting on a tree stump with a basket of flowers on their lap. (Group B)

On this particular box, the painting is completely different than the painting style done by the Conta & Boehme painters. Note the facial features (not as childish with rosy, puffy cheeks) and the hair which is done in dark, thin brush strokes. These darker strokes are unlike the Conta & Boehme pieces. (SITZEN-DORF and several other companies used this painting technique.)

Stamped on the box, along with the Conta shield mark, is the stamp **L & R Germany**. Our researcher has found one similar mark by Lorenz & Reichel. This porcelain factory was founded in 1902 and changed into a joint-stock company in 1909. Therefore, this mark was used from 1902 to 1909. Whether they changed in 1909 to just the letters L & R, we have not yet established.

This same L & R mark can be found on many items pictured in the Conta & Boehme product catalog such as candelabras, figurines, etc. This company apparently purchased the Conta & Boehme molds after the closing in 1931.

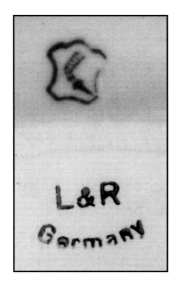

Plate 18

Conta shield mark done in
a blue ink stamp along
with the mark
L & R
Germany.

Plate 19

Lorenz & Reichel
Schirndingen/Bavaria

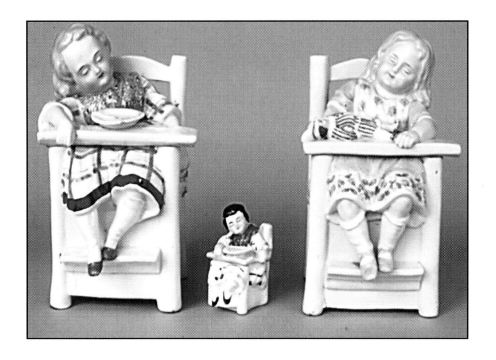

Plate 20: a b c Conta & Boehme

a) Child asleep in high chair. Bowl and spoon on feeding tray. Model number 2521, II (size number), and number 15 incised on cover. (MATE: ?) (Group D) (Pair: Group E)

b) **MINIATURE:** Same as above. 2-1/2" tall. Number 35 incised on cover. (See Plate 30-b.) (Group A)

c) Child asleep in high chair. Jester doll on feeding tray. Conta shield, model number 2590, II (size number), and number 32 impressed on cover. Raised Conta shield mark only on base. (Group D) (Pair: Group E)

MATE: Boy in high chair with a toy horse lying on feeding tray. Conta shield and model number 2591.

CHAPTER IV

Excavated Porcelain Fragments

uring the 117 years of operation, more than 10,000 differ-
porcelain articles were produced at the Conta & Boehme
porcelain factory.

Trinket boxes were not manufactured during the early years
of the company. This trend changed when the two brothers drasti-
cally altered their production in 1840 (following the death of their
mother who resisted change) from dishes to porcelain figures,
knickknacks, and toys. The model designers at Possneck during
the second-half of the 19th century used so much imagination that
the products were in great demand. Only a small portion of the
articles were sold in Germany. The majority were exported,
primarily to England and America. This is the reason for the
relatively frequent occurrence of Conta & Boehme porcelain in
the U.S. while there are very few pieces in German collections or
museums.

Because there was always a large amount of reject material
in the porcelain industry, it is estimated that approximately 10%
of the total production could not be used. The clay molds as well
could only be used for a certain length of time. As there were no
city dumps, holes on the company property plus uneven terrain
and swampy ranges, were filled in with these fragments. The
factory workers were not able to purchase the porcelain because
they did not have enough money; therefore, as a substitute, they
took porcelain pieces home from the extensive rejects to decorate
their dwellings or gave them to their children as toys. The reject
porcelain is almost always white as the mistake usually occurred
at the main burning before the paint was applied. When the porce-
lain broke, it was put in the garbage behind the house. Since many
of the porcelain workers also farmed their land, this compost

including the porcelain fragments, was scattered in the fields as fertilizer over a period of 100 years. With luck and perseverance, one can still find old porcelain pieces, including trinket boxes, throughout the fields surrounding the Possneck factory.

This chapter illustrates fragments found in the top soil as well as fragments from excavations at the factory site and neighboring surroundings. The majority of pieces are not painted and are damaged, but can be reconstructed.

The oldest of these pieces is a simple, oval cover. A young woman with wide skirt is molded in the middle. She is holding a basket with a handle. This trinket box cover (Plate 21-a) carries traces of the end of the Biedermeier era (a simple yet elegant style developed in southern Germany and Austria early in the 19th century) and is probably from circa 1840 to 1845.

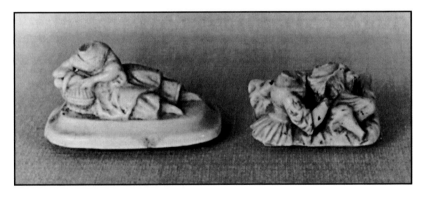

Plate 21: a b

Representing the Rococo era (18th century, very ornate design) (Plate 21-b) is a woman wearing a fashionable dress sitting on a large pillow or bed with her child. Her left arm is placed around the child. The period for this box is probably between 1845 and 1850.

A third box may be categorized as belonging to the same time frame. This box is substantially larger than the ones described on the previous page. A gentleman is sitting in front of a lady wearing a wide hoop skirt. The upper half of the trinket box forms the cover. *It was customary during this time period to place the cover on the lower portion of the trinket box during the firing process in the kiln. This guaranteed that the pieces fitted precisely to one another.* It also happened; however, that both halves often melted together as was the case with this box. In addition, the figures on the cover sank because of the extreme temperature.

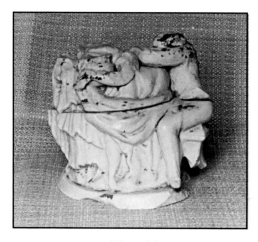

Plate 22

These three trinket boxes help illustrate the clean and precise modeling work of the figures. The details are brought out exactly. The glaze is applied in a very thin layer so that the fine point of the sculpturing is not lost. These three pieces are quite heavy as compared to the later boxes. There are no trademarks or numbers on any of them.

As there was very little competition in the manufacture of these porcelain trinket boxes, they were in great demand, especially in America. For this reason, the variety of shapes were expanded considerably during the 1850's, as the model designers were given free creative reign.

The following fragments are from the time period of 1850 to 1891 and have helped in identifying unmarked pieces. Many of the items on the covers have been broken off, but the photos still show the shape of the covers or bases for reference along with any identifying numbers.

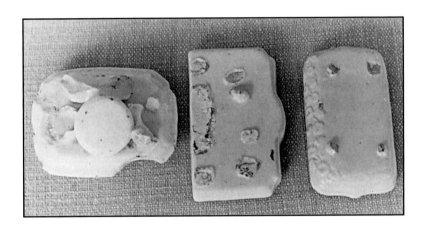

Plate 23: a b c

a) Cover with mirror, mirror frame broken off. On top sits a pocket watch, other objects broken off. Unpainted. No trademark.

b) Cover to the fireplace base, dresser type box with mirror; mirror frame and other parts broken off. Unpainted. Impressed with the Conta shield and model number 3655.

c) Cover to a 3-spot base with parts broken off. Unpainted. No trademark, model number 101.

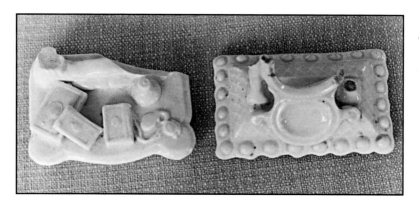

Plate 24: a b

a) Cover in the form of a dresser with mirror, mirror frame broken off. Three books, eyeglasses, and a candleholder. Unpainted. No trademark.

b) Cover with mirror, mirror frame broken off. The edge is decorated with round, raised half-circles. Unpainted. No trademark.

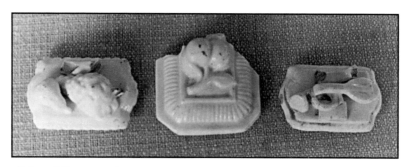

Plate 25: a b c

a, b) Cover with fruit on top. Unpainted. No trademark.

c) Cover with mirror, mirror frame broken off. Trumpet, lute, and book. Traces of gold remaining. No trademark. Impressed with model number 34, II (size number), and number 41.

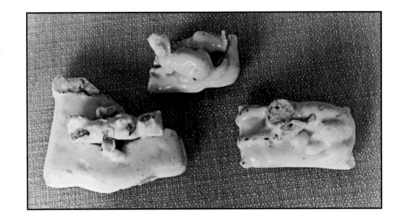

Plate 26:
 a
 b c

a) Cover. Seated dog with a small child lying next to it. Only one leg of child still remains. Unpainted. Impressed with the Conta shield.

b) Cover with mirror, mirror frame broken off. Animal lying on its back between the legs of a child (body broken off). Unpainted. Impressed with the Conta shield and model number 3578.

c) Cover with dog lying on a pillow. Head broken off. Unpainted. No trademark.

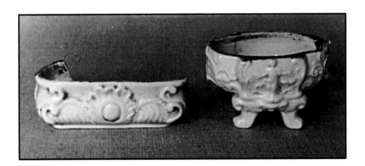

Plate 27: a b

a) Base of what is referred to as a 3-spot base. Unpainted. No trademark.

b) Base of trinket box with feet. Unpainted. No trademark.

Plate 28: a b
 c d

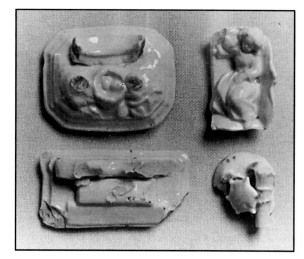

a) Cover, dresser type with mirror. Mirror frame broken off. Bird nest with two eggs rests on the cover. Impressed with the Conta shield and model number 3534.

b) Cover in the shape of a sofa with a girl lying on it. She is wearing a long dress or night gown. Unpainted. No trademark.

c) Cover in the shape of a parlor organ. Unpainted. No trademark.

d) Oval cover with fragments of some thread wound on a star-shaped piece of cardboard and a small container of needles. Unpainted. No trademark.

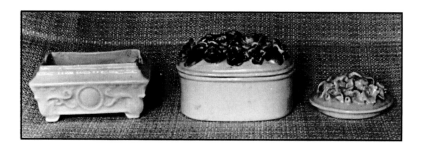

Plate 29: a b c

a) Rectangular base with small feet. Unpainted. No trademark.

b) Oval box, no decoration on lower section, a colorfully decorated flower bouquet on the top. No trademark.

c) Cover to a round box with a flower bouquet on it. No trademark.

Plate 30: a b

Miniature boxes

a) Fragment of a cover, rider on a horse. Paint still visible. No trademark.

b) Lower section of a box. Girl (legs and skirt) sitting in a child's high chair. Some paint still visible. No trademark. Incised with number 137 on the bottom.

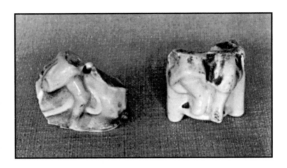

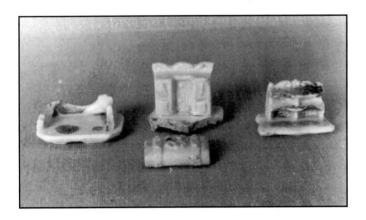

<div style="text-align:center">a b c</div>

Plate 31: d

Miniature boxes

a) Cover in the form of a small commode with mirror, mirror frame and added pieces broken off. No trademark.

b) Cover in the form of a small cabinet with suggestion of drawers. Unpainted. No trademark, raised model number 24. (See Plate 13, top.)

c) Cover in the form of an old woodburning stove with shelves. Unpainted. No trademark.

d) Cover in the form of a small trunk lid. Unpainted. No trademark.

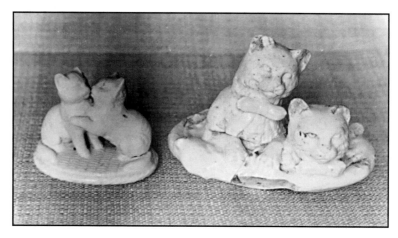

Plate 32: a b

a) Cover in the shape of an oval basket. Two cats playing on the basket cover. Unpainted. No trademark.

b) Cover in the shape of an oval basket. Two cats peek over the edge of the basket. (This cover belongs to the fairing box captioned: *After The Race 1875*) Unpainted. No trademark.

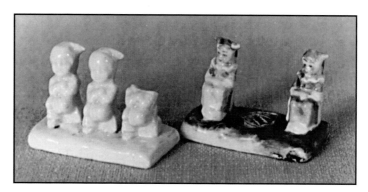

Plate 33: a b

a) Cover with three small, seated boys wearing knitted caps. One head broken off. Unpainted. Impressed with the Conta shield and model number 84.

b) Cover with three small, seated girls. Middle girl broken off. Partially painted. No trademark.

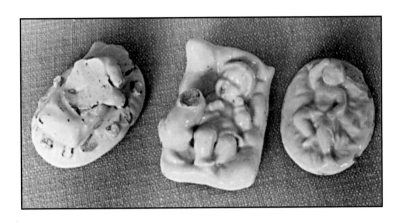

Plate 34: a b c

a) Oval cover, edge decorated with rosettes. Child sitting on a pillow, upper
 body and feet broken off. Unpainted. Impressed with the Conta shield and
 model number 171.

b) Cover with a small child lying on a pillow, a cat (?) sitting next to the child.
 Head of the cat broken off. Unpainted. No trademark.

c) Oval cover with a small child lying on it. Unpainted. No trademark.

Plate 35: a b

a) Lower part of a box in
 the shape of a paddle
 boat; bow and stern
 broken off. Unpainted.
 No trademark, number
 46(?).

b) Cover in the shape of a
 bed. Clothing lies over
 the bedpost. Unpainted.
 No trademark.

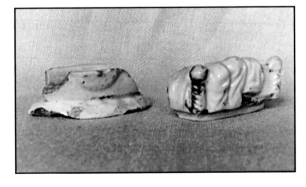

Plate 36: a b

a) Oval cover with notched edge. A lady with a wide skirt is bending forward, she probably had a partner facing her. Unpainted. No trademark.

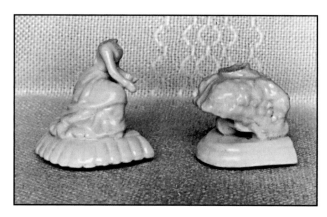

b) Oval cover with a wheelbarrow containing hay. A small child is sitting on the hay (broken off). The wheelbarrow was probably pushed by a man. Unpainted. No trademark.

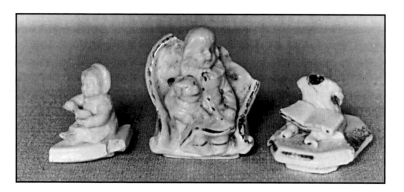

Plate 37: a b c

a) Fragment of a cover with small child eating with a spoon. Unpainted. No trademark.

b) Cover in the form of an upholstered chair. A girl is seated on the chair with a dog. Partially painted. No trademark.

c) Eight-sided cover with a child seated with a book. Head and arms broken off. Gold edge. No trademark, number 36.

Plate 38:

a b c
d e f
g h

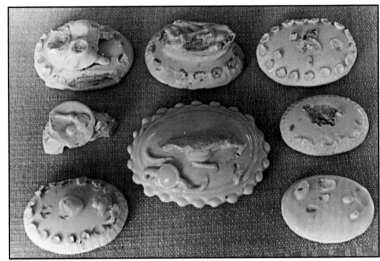

a) Oval cover, edge decorated with rosettes. Woman sitting in the middle. Upper body broken off. Unpainted. Impressed with the Conta shield and model number 149.

b) Oval cover, edge decorated with rosettes. In the middle is a boat with a man at the rudder. Upper body broken off. Unpainted. Impressed with the Conta shield and model number 90.

c) Oval cover, edge decorated with rosettes. Parts broken off. Unpainted. No trademark.

d) Oval cover, edge decorated with rosettes. Parts broken off. In the center stood a child (only one foot is left). It appears the child is holding a doll upside down with its head hanging in a bowl. No trademark, number 151.

e) Oval cover, edge decorated with curled ribbon. The center decoration broken off. A ribbon is attached with a heart on it. Unpainted. No trademark.

f) Oval cover. The edge is ribbed. A plant ornament is toward the front. Other parts broken off. Unpainted. No trademark, number 37.

g) Oval cover, edge decorated with rosettes. In the middle is a heart with an anchor (broken off). Unpainted. No trademark, number 16(?).

h) Cover for a box in the form of a basket. (Similar to Plate 32-a.) Cats broken off. Unpainted. No trademark.

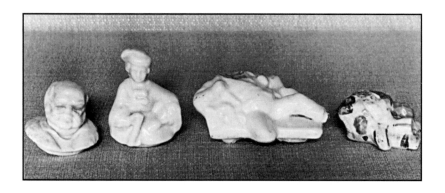

Plate 39: **a** **b** **c** **d**

a) Cover representing the head of an elderly gentleman with glasses. Unpainted. No trademark, number 44.

b) Cover representing the upper body of a hunter with a rifle. Unpainted. No trademark.

c) Cover of a man lying comfortably on a chaise lounge. Head and foot broken off. Unpainted. No trademark.

d) Same as figure "c" but smaller; remainder of paint visible. No trademark.

Plate 40:

An oval box (drawing of the original), edge decorated with rosettes, flower grouping at the center. The lower pedestal base section is shaped as if it were a cloth hanging over the edge in folds with rosettes around the top edge. No trademark.

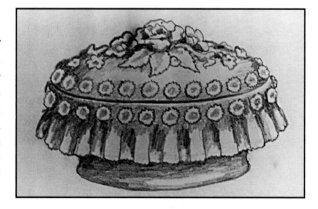

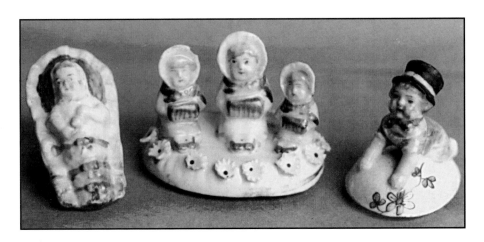

Plate 41: a b c

a) Cover of infant holding a rattle lying on pillow in blanket covered basket (bunting). Three straps with bows hold infant in bed. Green pillow, blue straps and bows, light brown hair. No trademark.

b) Oval cover, edge decorated with rosettes. Three seated girls (three little maids) with bonnet, shawl and muff. Impressed with the Conta shield and model number 160.

c) Cover in shape of an egg decorated with colored flowers. Child in black top hat kneeling. Impressed with the Conta shield and model number 78.

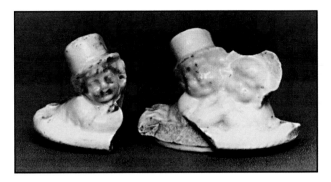

Plate 42:

Oval cover representing the top of a basket with boy and girl in an embrace.
Unpainted. No trademark.

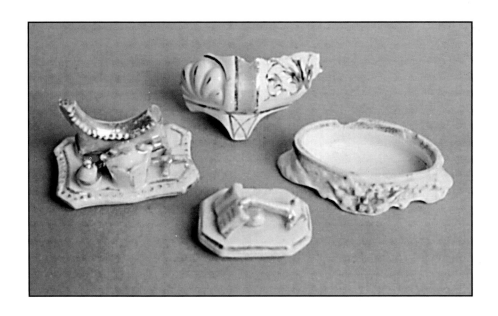

b

a c

Plate 43: d

a) Cover with a large and small crown, and a cross. Mirror frame partially broken off. No trademark.

b) Base decorated in gold with a wide blue stripe on each corner. Sides have fan-shaped design while the front is decorated in a leaf design painted in gold. No trademark.

c) Oval base with leaf and berry design, trimmed in gold. No trademark.

d) Rectangular cover with open book, anchor (partially broken), and an orange ball. Decorated in gold trim. No trademark.

The charm of the **Victorian Trinket Box** lies in the wide variety of subjects and decorations adorning the covers. Children, adults, animals, flowers, boats, etc. are often chosen as a specialty group by collectors. Some of the boxes will portray Kate Greenaway figures on the lids. Kate Greenaway was an English children's illustrator and painter during the last quarter of the nineteenth century. (Born 1846, died 1901)

Box styles are nearly as varied as box subjects. Bureau or dresser; vintage; one-, two-, and three-spot; fairing; miniature; figural; basket; furniture; etc. Interestingly, the identical box subject can be found on two or more box styles, especially between vintage and bureau/dresser boxes. In both of these styles, you will find that many of the boxes contain an ornate gilded frame at the back of the cover which originally held a small mirror with paper backing. Most of the mirrors have long since disappeared. Some collectors have the mirrors replaced; others find the boxes quite attractive without them. One can even find the exact box manufactured without the mirror frame.

Figural styles deserve a special note. Figurals come in three different types. (1) The "full figure," usually brilliantly colored, gives the effect of a solid figurine which separates to form a box; (2) the "half body" which is made from the waist upwards and separates at the shoulder; and (3) the "pedestal figure" in which the cover is the figure and the base is a stand or pedestal for it.

Sometimes trinket boxes are confused with inkwells or matchboxes. When inkwell covers are raised, the base contains the inkpot and sander. A combination trinket box and inkwell will have the pot and sander attached to the front of the box. Matchboxes will have a ribbed striking surface under the cover or along one of the sides.

Trinket boxes with identical subjects and styles may come in several different sizes. We have seen up to nine sizes of the same box; however, three sizes seem to be the norm for most boxes. When using our price guide, the range selected depends on the

size of the box. Not all sizes will fit in the same price range even though they are the identical box. (See Plate 100.)

Many boxes come in pairs, girl/boy, woman/man, etc. The value of a pair exceeds individual pieces and is shown in our pricing group.

Several boxes have unidentifiable marks or numbers on the bottom of the cover or base. We have simply listed them for your reference. If a model or mold number is known, it is listed as such.

Although we feel many of the unmarked boxes were manufactured by Conta & Boehme, we prefer to catagorize them as unknown until we can prove them to be Conta & Boehme. Proof may be provided by locating an identical box which is marked or could consist of a museum documentation.

We welcome the assistance of any of our readers who could identify any of the unknown boxes.

On the following pages, we chose to display an assortment of each box style. Keep in mind that hundreds of boxes were made in each style.

Enjoy.

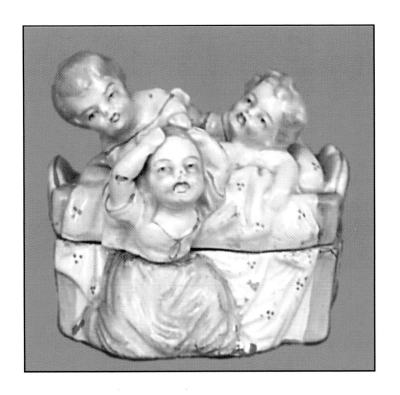

Plate 44: **Conta & Boehme**
(Circa 1840—1850)

Three adorable children wrestling in bed. This box is very
heavy, painted in only one color, either blue or pink, with no
gold. Unmarked. (Group C)

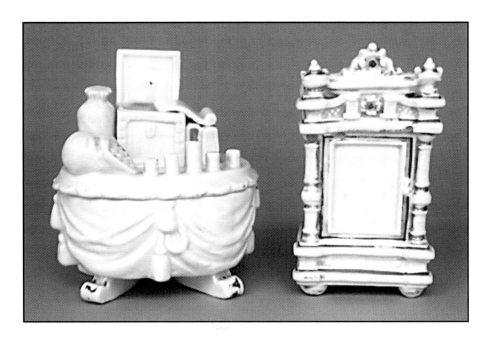

Plate 45: **a** **b**
Conta & Boehme
(Circa 1845—1850)

a) A cloth draped table with tassels on all four sides. On top sits an open money box, two ledger books, a talley sheet, two bags of coins (one opened), and five stacks of coins. Unmarked. (Group C)

b) An elaborate standing floor safe. Unmarked. (Group C)

 The inspiration for these two boxes could have come from the Conta brothers themselves. By the end of the 1840's, the product change from dishes to knickknack and decorative items proved to be a huge success. Both boxes are still quite heavy, again with only one color. However, they now have traces of gold.

Plate 46: a b Maker unknown

a) Full figure of a lady on a donkey while a man pushes the donkey from behind.

b) Full figure of three children, boy and two girls, playing around an arm chair. The girl standing behind the older girl is hiding her face with her hands. A doll is lying on the chair beside the boy.

Plate 47 Maker unknown

a) Full figure of a child asleep in bed with a guardian angel.

Plate 48: a b Maker unknown

a) Full figure of father, mother and small child. Father wearing a cloak, mother with long veil. (Courtesy of Suzanne & Edwin Meyer)

b) Full figure of father, mother and child. (Courtesy of Suzanne & Edwin Meyer)

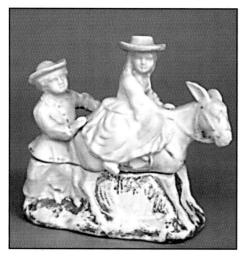 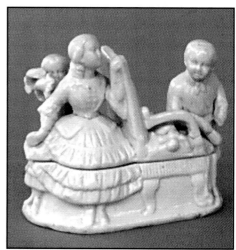

On these boxes, only part of the box is glazed while the rest is unglazed. Gold is the only color used. The detail is well done. They are still heavy, but not as heavy as the boxes pictured in Plates 44 and 45. They were probably made towards the end of the 1840's or the beginning of the 1850's. Unmarked. The maker could possibly be Conta & Boehme. (Group B)

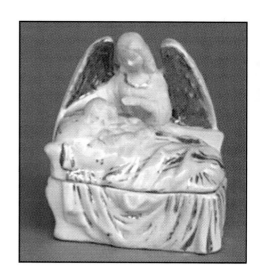

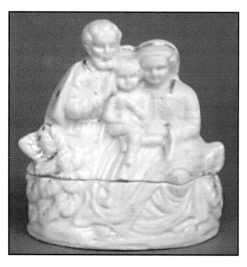 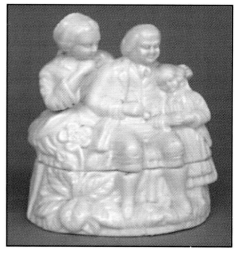

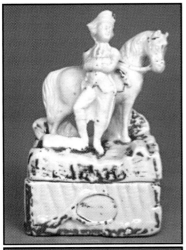

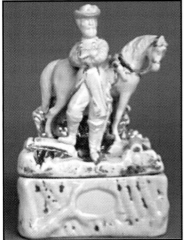

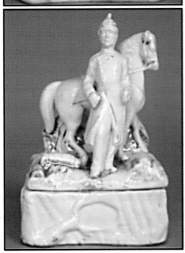

Plate 49: a b c
Maker unknown
(Circa 1840—1850's)

Combination bisque and glazed boxes. This same box can be found with many famous historical figures on the cover as well as in different sizes. The oval panel in the center of the base was written in gold with the person's last name. Many have been worn away. On all boxes, the figure and horse are left unglazed. The design and items remain the same, two artillery shells on the ground. Only the figure changes. These boxes are very heavy. Decorated in gold only. Unmarked. Possibly by Conta & Boehme. (Group C)

a) George Washington. On the oval panel in the center of the base, is still traces of gold spelling out *Washington.* (Courtesy of Suzanne & Edwin Meyer)

b) General Ulysses S. Grant.

c) German soldier (unknown).

Plate 50: a b c
Maker unknown
(Circa 1850—1860's)

On these three boxes, again only part of the box is glazed while the rest is unglazed. Gold is the only color used. The detail is still nicely done. The base is now oval with leaf and vine design. Unmarked. Possibly by Conta & Boehme. (Group B)

a) Lady sitting leaning against a hay stack. (Courtesy of Suzanne & Edwin Meyer)

b) Civil war soldier kneeling beside a tree putting apples into a basket. (Courtesy of Suzanne & Edwin Meyer)

c) Man and lady on cover. She carries a basket of flowers.

Fairing Boxes
(Circa 1850—1890)

These colorful boxes are what most collectors consider fairing boxes. According to Webster's Dictionary, the word fairing means: *a present bought or given at a fair.* In some instances, the very same ornaments on the cover can be found on the fairing figural groups with captions that were also very popular at fairs.

The boxes will be captioned either on the front of the base or on the side. They were intended to be humorous and some even a bit risque in order to please the fairgoers.

The leader and most prolific maker of these boxes was Conta & Boehme who manufactured over 400 different designs during the heyday of the "Fair."

Once other German porcelain makers saw how popular these small, whimisical fairings were, Conta & Boehme was no longer the sole provider. In order to compete, these copycat boxes were made of poor quality and workmanship. Although Conta & Boehme boxes are the most desired today, the copycat boxes are still collectible.

Fairings were manufactured in Germany; however, the designs and captions were supplied by the wonderful British humor. Some of these ideas were taken from such items as sheet music covers (Champagne Charlie) and English comic papers of the 1860's and 1870's.

Not all boxes with captions can be called fairings as they were not all sold at fairs. As fairs became less popular, the designs were changed to meet a more respectable class of buyer. Manufacturers began selling directly to gift shops, storekeepers, and bazaar dealers.

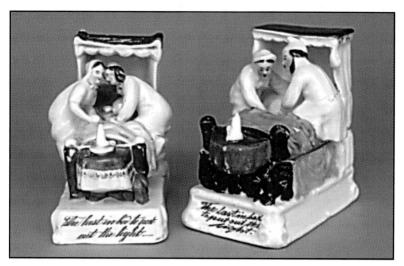

Plate 51: a b Conta & Boehme

Last in bed to put out the light

a) **One piece figurine.** Man and woman spring into bed simultaneously; a lighted candle on table at the foot of the bed. Conta shield, model number 2851, and number 79. (Group B)

b) **TRINKET BOX:** Unmarked. Circa 1860's. (Group C)

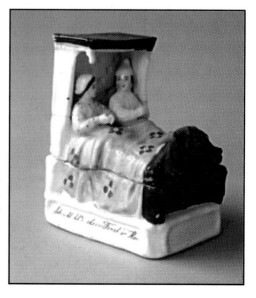

Plate 52: Conta & Boehme

Shall we sleep First or How?

TRINKET BOX: A man and woman sitting in bed twiddling their thumbs. Circa 1860's. Unmarked. (Group C) (Courtesy of Patricia French)

Many times the items portrayed on uncaptioned fairing figural groups were also used on trinket box covers. It is debatable whether these uncaptioned boxes are in the same category as uncaptioned fairings. As the boxes became more popular, shop owners in almost every town began selling them. Risque boxes were a favorite of many buyers, but could not be found in retail shops. Therefore, they remain in the fairing category. The following box is an example of a fairing piece only available through fairs. It portrays an older woman in bed with a younger man. Suzanne has jokingly captioned this box *"Lady and the Gigolo."*

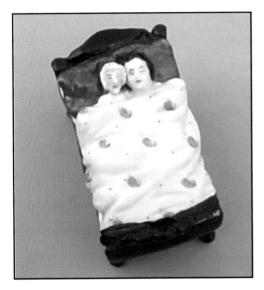

Plate 53: **Conta & Boehme**

Unmarked (Group D)
(Courtesy of Suzanne &
Edwin Meyer)

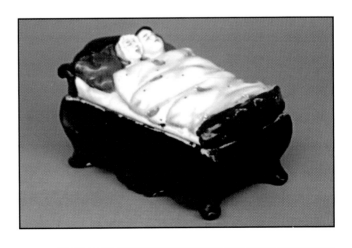

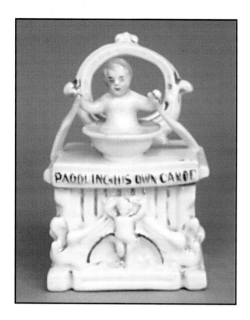

Plate 54: **Conta & Boehme**

Captioned: *Paddling His Own Canoe*

Boy sitting in a basin of water with two oars pretending to paddle. This box is from the song popularized by Harry Clifton in 1882. Model number 3555 and number 144 impressed on cover. (Group C)

Plate 55
Conta & Boehme

Captioned:
The child's prayer

Child sitting up in bed saying her prayers. Doll beside her. Raised model number 2910 and II (size number) on base. (Group C)

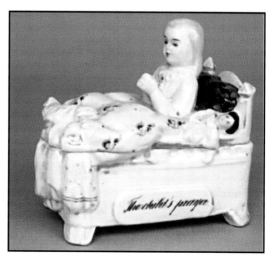

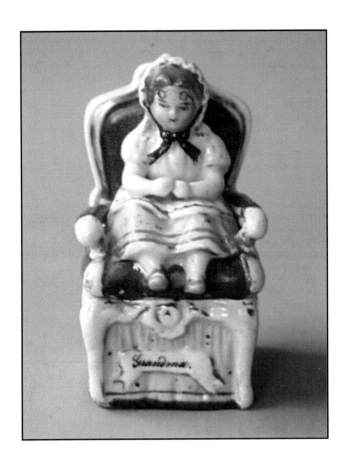

Plate 56: **Conta & Boehme**
Captioned: *Grandmama*

Girl sitting in armchair holding a ball. Spectacles on her forehead.
Model number 2194 and number 73 impressed on cover.

(MATE: Boy sitting in armchair holding a book and a
long-handled pipe. Captioned: *Grandpapa*)

(Group C) (Pair: Group D)
(Courtesy of Patricia French)

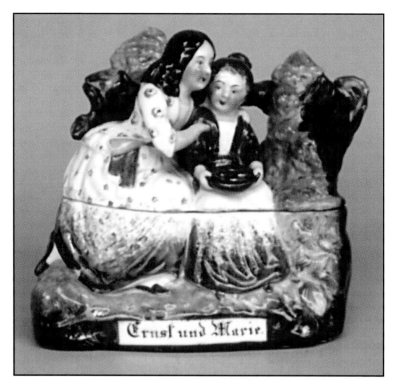

Plate 57: **Conta & Boehme**
Captioned: *Ernst und Marie*

Two children in forest. Boy holding a birds nest with four eggs in it.
Most likely taken from a German childrens storybook.
1860-1880
Unmarked
(Group E)

Some boxes are dated by the correlation of their decorations with known historical and political events or persons.

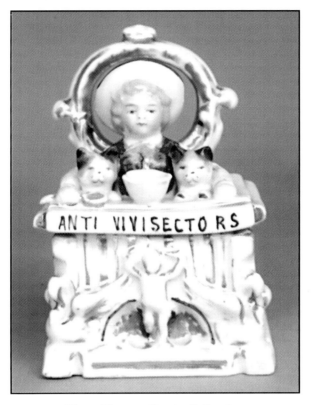

Plate 58: **Conta & Boehme**
Captioned: *Anti Vivisectors*

Child holding spoon with arms around two cats. Bowl in center. Conta shield, model number 3563, number 164, and the letter **P** impressed on cover. (Group D)

Many people opposed the operations on or the use of live animals for medical experiments. Anti-Vivisectionists believed it was cruel to use live animals for laboratory experiments, and that other research techniques might be better. These boxes are believed to have been sold to raise money for the Anti-Vivisectors Society, founded 1876 (or merely to publicize it). They are eagerly sought for historical value and appeal.

Champagne Charlie is a most interesting box. Over 100 years ago, a French wine company was established by Charles Heidsieck. Three nephews of Mr. Heidsieck left the original company and started their own firm (also called Heidsieck). One of the nephews was Charles, whose name still graces the company label.

Beginning in 1857, he and his son, also a Charles, made a series of sales trips to America to sell their premium quality champagne. Due to his flamboyant personality, dedication in selling, and personal enjoyment of his product, his American friends promptly nicknamed him "Champagne Charlie."

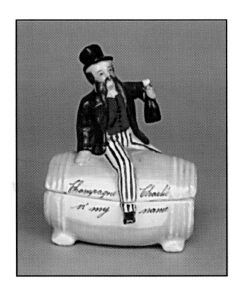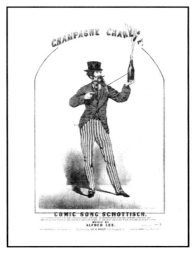

Plate 59: **Maker unknown**

Champagne Charlie is my name

Champagne Charlie sitting on a barrel holding up a bottle of champagne.
Unmarked (Group E)

This trinket box represents George Leybourne making popular the song "Champagne Charlie" and dates back to 1861-2. Note the dundreary whiskers which were first introduced by the comic actor, Edward Askew Sothern, during his visit to England in 1861.

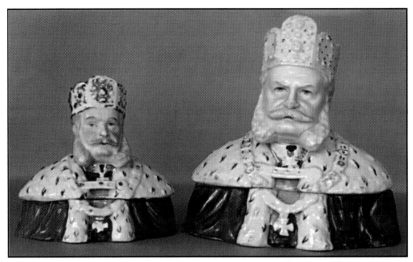

Kaiser Wilhelm I

Plate 60: **a** **b** **Conta & Boehme**

a) Model number 2954 incised on base. (Group D)

b) Unmarked. (Group D)

(This box is not considered a fairing, but in great demand for its historical value.)

Wilhelm I.
1797-1888

The box above depicts the bust of **Kaiser Wilhelm I** during his crowning in 1871 as the first emperor of a united Germany and proclaiming the year as **"the year of hope."** Franz Josef I (Francis Joseph), the ruler of Austria and Hungary, has been mistakenly attributed to this box. (The delicate cross is missing from the top of the crown on both boxes.)

NOTE: **Kaiser Wilhelm I** can also be found in a full-figured, 10-1/2 inch tall tobacco jar. He is sitting in a chair with small round table beside him signing a declaration. (Group E)

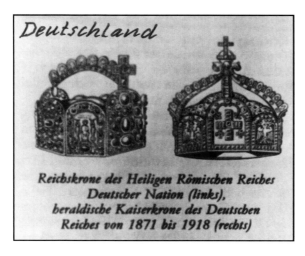

German
Crown

Reichskrone des Heiligen Römischen Reiches
Deutscher Nation (links),
heraldische Kaiserkrone des Deutschen
Reiches von 1871 bis 1918 (rechts)

Plate 61

German crown worn by Wilhelm I during his crowning.

Austrian
Crown

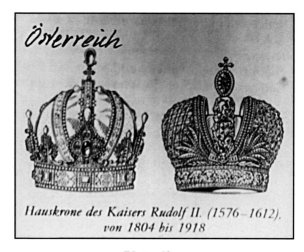

Hauskrone des Kaisers Rudolf II. (1576–1612),
von 1804 bis 1918

Plate 62

Austrian crown worn by Franz Josef I, ruler of
Austria and Hungary at the beginning of World War I.

Three-Spot Boxes
(Circa 1850—1890's)

This group is commonly called three-spot boxes. This was derived from the three colored circles or spots on the front of the base. They were made approximately the same time as the fairing boxes and also number in the 400's. Some people specialize in collecting just this type. They display people in every imaginable way. There are serious boxes depicting the Crimean War (1854-6), patriotic, amusing boxes depicting family life in a very humorous fashion, as well as children and animals. These boxes were sold at fairs along with the fairing boxes. They can be found in two styles, matchbox or trinket box. The only diference will be the striking surface of the matchbox which is located on the underside of the cover. In order to tell the two apart, you must lift up the cover. For this reason, we have pictured both match and trinket boxes in this section. Conta & Boehme is the creator of the three-spot.

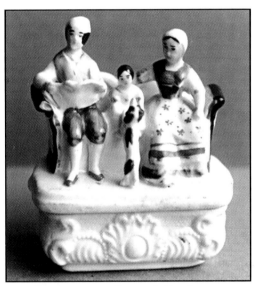

Plate 63: **Conta & Boehme**

MATCHBOX: Father, child and mother sitting on sofa.
Father reading a newspaper while child plays with dog.
Unmarked (Group C)

Courtesy of Hans Walter Enkelmann, Germany

Plate 64

Although uncaptioned, this box has been attributed to "Columbia" (a female personification of the United States of America who is usually represented as a tall, stately woman dressed in flowing white robes, wearing a slightly peaked hat with five-pointed stars on it, and holding an American flag).

This box with the American flag is very collectible. The number is illegibly incised on base. (Group D) (Courtesy of Suzanne & Edwin Meyer)

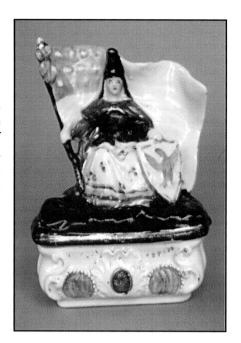

Plate 65

Zouave soldiers. Zouaves are soldiers of certain infantry regiments in the French army. The name comes from that of the Zouaoua tribe of Kabyles in Algeria, where Zouaves were first recruited in 1830.

They wear an unusual, bright colored uniform with a short jacket, baggy red or blue trousers, leggings, and a tassle cap or turban. They drill with a short, snappy step.

During the Crimean War, the Zouaves advanced to the assistance of the British at the Battle of Inkermann, November 6, 1854. Unmarked. (Group D)

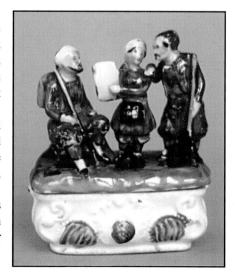

Plate 66: a b c

a) **MATCHBOX:** Mother sitting with arm on child's shoulder. Boy stands with both hands in his pockets. Model number 2140 incised on base. (Group C) (Courtesy of Patricia France)

b) **MATCHBOX:** Mother sitting in chair while she measures the height of her daughter and son. Model number 2160 incised on base. (Group C) (Courtesy of Patricia France)

c) **TRINKET BOX:** Girl lying on a chaise lounge with doll. Boy sitting on back blowing a horn. Unmarked. (Group C) (Courtesy of Patricia France)

Plate 67: a b c

a) **MATCHBOX:** Lady asleep in chair. Two children on table playing a practical joke on her. It appears they are unraveling her knitted shawl. Model number 2146 incised on cover rim. (Group C) (Courtesy of Suzanne & Edwin Meyer)

b) **MATCHBOX:** Man and lady sitting on the sofa having tea. A bird is on the back of the couch. Unmarked. (Group C) (Courtesy of Suzanne & Edwin Meyer)

c) **MATCHBOX:** Two ladies, one with a child on her lap, the other a basket. Man stands behind them. Model number 2143 incised on cover. (Group C) (Courtesy of Suzanne & Edwin Meyer)

Plate 68: a b c

a) **MATCHBOX:** Man and lady sitting on a sofa courting while a chaperon stands behind them. Model number 2181 incised on base. (Group C) (Courtesy of Suzanne & Edwin Meyer)

b) **TRINKET BOX:** Man and lady sitting at table playing checkers. Second lady stands behind watching. Unmarked. (Group C) (Courtesy of Suzanne & Edwin Meyer)

c) **TRINKET BOX:** Boy with goat and dog. Unmarked. (Group C) (Courtesy of Suzanne & Edwin Meyer)

Plate 69: a b

a) **MATCHBOX:** Father carrying child (holding a play sword) on his back while mother walks beside them with a cane. Another child sitting in a basket beside father. Number 212 incised on base. (Group C)

b) **TRINKET BOX:** Same as above. Number 102 impressed on cover. (Group C) (Courtesy of Suzanne & Edwin Meyer)

Trinket Box and Inkwell

Many of these full-figured boxes can be found in both a trinket box and inkwell. When the cover is lifted for the ink, two pots are exposed, one for ink, the other a sand pot. These boxes are very colorful, quite heavy, and come in a large assortment of designs.

Plate 70: a b Conta & Boehme

a) Lady playing the piano while a man accompanies her on the flute. Unmarked. (Box: Group C) (Ink: Group D)

b) Lady sitting at piano while man sits beside her in chair. He has his arm around her shoulder in an affectionate embrace. Impressed model number illegible. I (size number). (Box: Group B) (Ink: Group D)

Trinket box and inkwell combination. This style also comes in an assortment of different designs such as the large and small crown, sword, and scepter box.

Plate 71: **Conta & Boehme**

Table set with teapot, creamer, bowl, and two cups/saucers. Attached to the front of the trinket box is an ink holder and sander, each with a cover. The cover on right was missing when the box was purchased. It has been replaced with one dug at the factory site. Model number 3202 and number 104 incised on base. (Group C)

Pen and Ink Holder
(Circa 1880's)

Plate 72: **Conta & Boehme**

Two boys fighting during a card game.
Unmarked. (Group E)

Courtesy of
Mr. Helmet Scherf, Curator
Thuringer Museum in Eisenach, Germany

Miniature Boxes

These boxes are so very tiny they could possibly have been made as toys. They come in an assortment of designs from furniture to dishes and range in size from 1 inch to 3 inches tall.

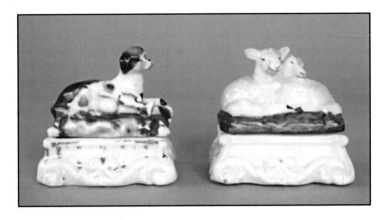

Plate 73: a b Conta & Boehme

a) Dog with horn and ball. 2-1/2" tall. Unmarked. (Group A)

b) Two lambs. Number 253 incised on cover. 2-1/2" tall. (Group A) (Courtesy of Suzanne & Edwin Meyer)

Plate 74: Maker unknown

Pocket billiard table with one red ball, two yellow balls, and a cue stick.
1-1/2" tall, 3-1/2" long.
Unmarked. (Group B)

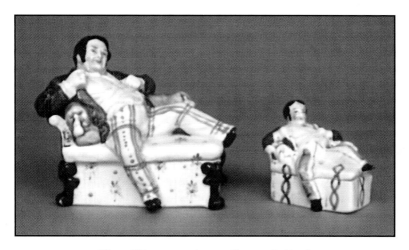

Plate 75: a b Conta & Boehme

a) **MATCHBOX**: Man reclining on a chaise lounge smoking a cigar. Model number 1939 incised on base. (See Plate 39- c.) (Group C)

b) **TRINKET BOX**: Miniature, same as (a). 2" tall. Model number 38 and II (size number) incised on base. (See Plate 39- d.) (Group A)

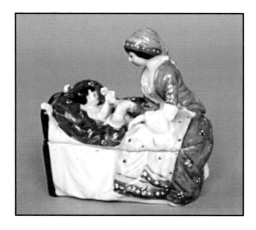

Plate 76: Conta & Boehme

Mother sitting at foot of bed while child plays with its toes.
Model number 296 and number 160 incised on base.
3" tall, 3" long (Group B)
(Courtesy of Suzanne & Edwin Meyer)

Plate 77: a b c Conta & Boehme

a) Man and lady sitting at a small table. In the larger version, they are playing checkers. 1-7/8" tall. Unmarked. (Group A) (Courtesy of Suzanne & Edwin Meyer)

b) Child sitting in chair while mother holds a picture frame in front of the child's face. 2" tall. Unmarked. (Group A) (Courtesy of Suzanne & Edwin Meyer)

c) Mother and father admiring their infant lying in a sleigh bed. 2-1/8" tall. Unmarked. (Group A) (Courtesy of Suzanne & Edwin Meyer)

Plate 78: a b c Conta & Boehme

a) **KATE GREENAWAY:** Three little maids with bonnet and muff sitting on a log. This type log box comes with many different figures on top, all in threes. Cats, dogs, Hessian soldiers, boys, girls, combination of boys/girls, etc. 2-1/4" tall. Conta shield and model number 76 impressed on cover. (See Plate 33-a, b.) (Group A)

b) Little girl with bonnet lying on grass. 1-3/4" tall. Conta shield and model number 90 impressed on cover. (Group A) (Courtesy of Suzanne & Edwin Meyer)

c) **KATE GREENAWAY:** Boy with horn. (Tom, The Piper's Son) 2-1/4" tall. Unmarked. (Group A)

Plate 79: a b Conta & Boehme

a) Child in black top hat kneeling on egg. 2-3/4" tall. Conta shield and model number 78 impressed on cover. (See Plate 41-c.) (Group A)

b) Organ grinder with monkey sitting on grass. This is a "One-spot" base box. 2–3/4" tall. Unmarked. (Group B) (Courtesy of Suzanne & Edwin Meyer)

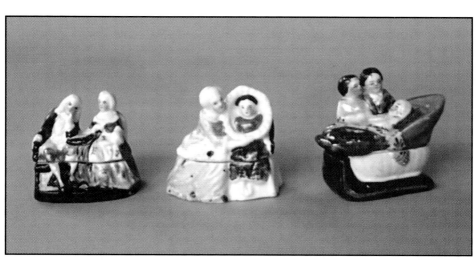

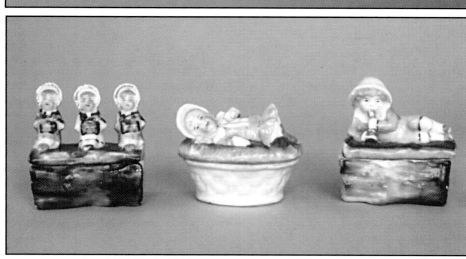

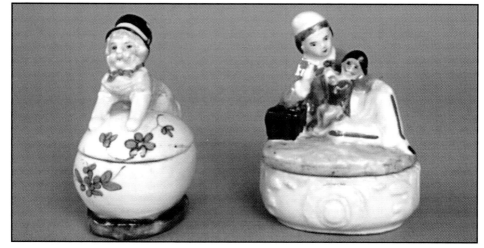

Plate 80: a b c Maker unknown

a) Swan on lake. 2-1/4" tall. Unmarked. (Group A) (Courtesy of Suzanne & Edwin Meyer)

b) Cat in forest. 2-1/4" tall. Unmarked. (Group A) (Courtesy of Suzanne & Edwin Meyer)

c) Hen on nest, trimmed in blue flowers. 2" tall. Unmarked. (Group A) (Courtesy of Suzanne & Edwin Meyer)

Plate 81: a b Maker unknown

a) BOY sitting on large dog. 2-3/4" tall. Unmarked

b) GIRL sitting on large dog. 2-7/8" tall. Unmarked

(Group A) (Pair: Group B) (Courtesy of Suzanne & Edwin Meyer)

Plate 82: a b Maker unknown

a) Barefoot girl sitting on a tree stump. 3" tall. Unmarked. (Group B) (Courtesy of Suzanne & Edwin Meyer)

b) Boy sitting with arm around a young lady. 2-1/4" tall. Unmarked. (Group B) (Courtesy of Suzanne & Edwin Meyer)

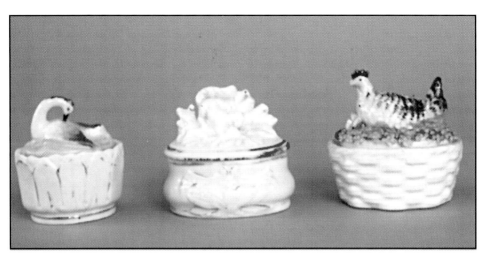

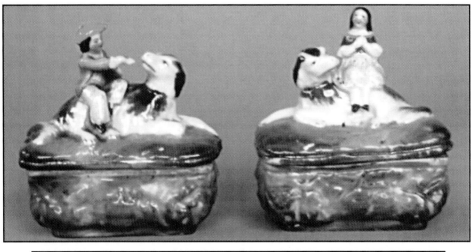

Vintage Boxes
(Circa 1850—1890's)

These boxes have small oval bases trimmed in gold and embossed with vines and leaves. The covers are encircled by little gilded rosettes and display animals, children, ships, etc. They can be found with or without the mirror frame. The cover can also be found with a ribbed edge instead of the tiny rosettes. They come in several sizes and in at least two different designs.

Some can be found with the Conta shield mark impressed while others only contain the incised model number. They were all made by Conta & Boehme.

Plate 83: a b c

a) Boy with stick holding onto a large dog. Mirrored. Model number 25 impressed on cover. (Group B)

b) Uncaptioned Anti-Vivisectors box. (See Plate 58.) Conta shield, model number 154, and number 130 impressed on cover. (Group C)

c) Same as (a) but without mirror. Model number 118 impressed on cover. (Group B)

Plate 84: a b c

a) Child feeding chicken in front of fence. Model number 99 incised on cover. (Group B)

b) Girl sitting at a table eating out of a bowl. Model number 69 incised on base. (Group B)

c) Two children, each sitting on a chamber pot. Girl holds doll. Model number 41 incised on cover. (Group B)

Plate 85: a b c

a) Cluster of fruit (grapes, pear, apple, and peach). Model number 66 incised on cover. (Group B)

b) Three cherries on a branch. Model number 103 incised on cover. (Group A)

c) Child (with spoon) crying while cat eats from the child's dish. Unmarked. (Group B)

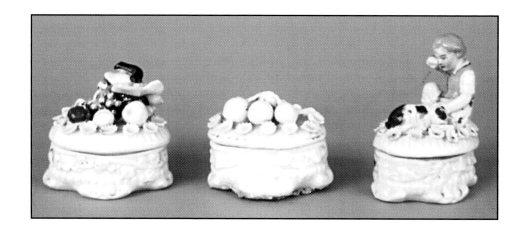

Plate 86: a b c

a) Steam engine locomotive. Model number 97 incised on cover. (Group B) (Courtesy of Suzanne & Edwin Meyer)

b) Angel lying on cover. Unmarked. (Group B) (Courtesy of Suzanne & Edwin Meyer)

c) An open book and gold anchor are resting on a red heart. Note the slight difference in the design of the base and the height. This box is also thinner and lighter than the other boxes. Unmarked. (Group B) (Courtesy of Suzanne & Edwin Meyer)

Plate 87: a b c

a) Two cats sitting under open umbrellas. Unmarked. (Group B)

b) Boy reading a book while girl tries to steal a kiss. Model number 111 incised on cover. (Group B)

c) Girl holding up a cluster of grapes while kneeling in front of a basket of fruit. Conta shield, model number 158, and number 109 impressed on cover. (Group B)

Plate 88: a b c

a) Child sitting up in wooden cradle, waving. A covered jar on either side of her. Unmarked. (Group B)

b) Dog standing on hind legs holding a gold cane. Beside him is a ham and a link of sausage. Conta shield, model number 141, and number 94 impressed on cover. (Group B)

c) Child in clown outfit playing the drums. Unmarked. (Group B)

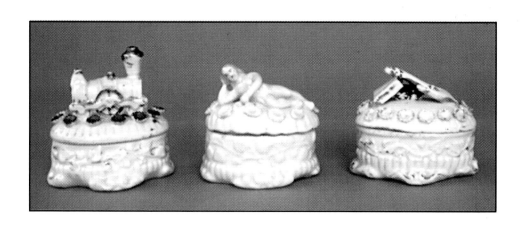

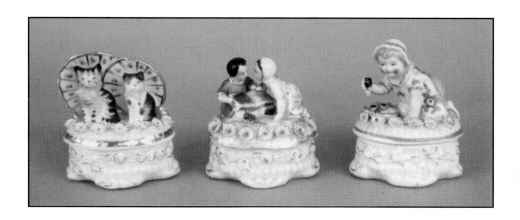

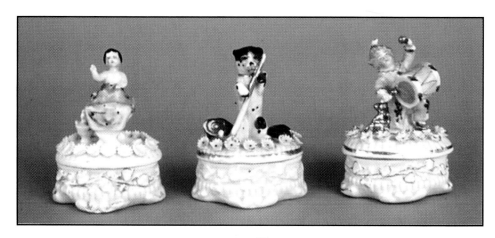

Plate 89: a b c

a) Ladies RIGHT hand with ring on first finger. No rosettes. Unmarked. (Group A)

b) Paddlewheel steamer. Model number 94 incised on cover. (Group B)

c) Ladies RIGHT hand with ring on first finger. With rosettes. Unmarked. (Group A)

Plate 90: a b c

a) Girl kneeling holding a doll wrapped in a blanket. A pillow lies in front of her. Model number 130 impressed on cover. (Group B) (Courtesy of Suzanne & Edwin Meyer)

b) Little Red Riding Hood and The Wolf. Model number 136 impressed on cover. (Group B)

c) Little Red Riding Hood and The Wolf. This vintage box is smaller and without rosettes. Conta shield and model number 37 impressed on cover. (Group A)

Plate 91: a b c

a) Two chickens with two baby chicks. Unmarked. (Group B) (Courtesy of Patricia France)

b) Very colorful basket of assorted fruit. This box is not considered a vintage box. Unmarked. (Group B) (Courtesy of Patricia France)

c) Child lying in a rocking cradle. Model number 98 incised on cover. (Group B) (Courtesy of Patricia France)

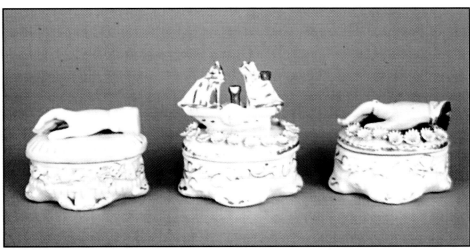

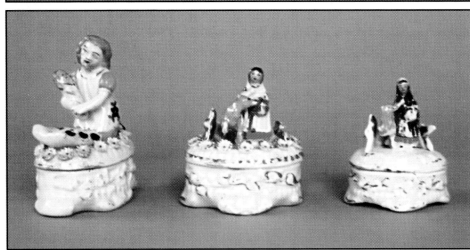

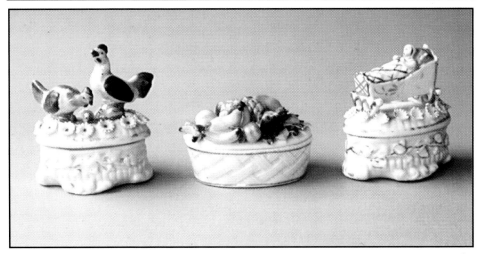

Plate 92: a b c

a) Archangel holding open book while child writes in it with a feathered pen. Unmarked. (Group B)

b) Mary and Her Little Lamb. Model number 255 and number 81 impressed on cover. (Group B)

c) Girl holding doll. Large bird standing beside fence. Model number 26 incised on cover. (Group B)

Plate 93

Cupid with bow and arrow lying on ground with fence in background. Note the long and narrow box with rosettes rather than the oval. The base represents a basket. Unmarked. (Group B) (Courtesy of Suzanne & Edwin Meyer)

Plate 94: a b c

a) Pocket watch, ring and seal stamp. Mirrored. Model number 102 impressed on cover. (Group B)

b) Two little girls in bonnets sitting. Conta shield and model number 162 impressed on cover. (Group B)

c) Large and small crown, sword, and scepter. Model number 86 incised on cover. (Group B)

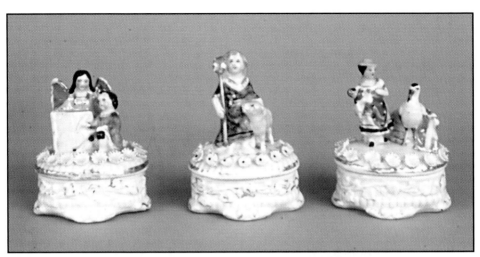

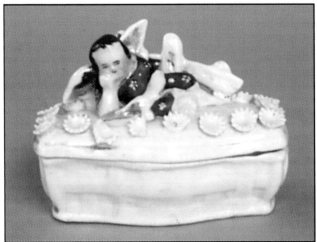

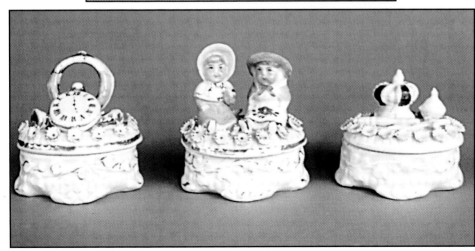

Plate 95

Child leaning on ladderback chair holding the end of a ball of yarn. Cat playing with the ball of yarn. Model number 82 incised on cover. (Group B) (Courtesy of Suzanne & Edwin Meyer)

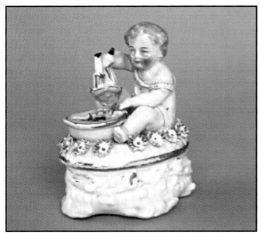

Plate 96

Girl sitting at table looking at a picture. Unmarked. (Group B) (Courtesy of Suzanne & Edwin Meyer)

Plate 97

Girl holding her doll by the legs dunking its head in a bowl of water. Unmarked. (See Plate 38-d.) (Group B) (Courtesy of Suzanne & Edwin Meyer)

Leaf and Berry Boxes
(Circa 1850—1870's)

This type of box is similar in size to the vintage boxes. The base has leaves on each end, leaves and three red berries in the center, and is very colorful. Made by Conta & Boehme. (See Plate 43-c.)

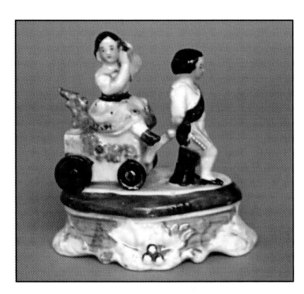

Plate 98

Boy giving girl a ride on a 4–wheeled wooden wagon. Number 244 incised on cover. Number 194 impressed on base along with an incised I (size number). (Group C) (Courtesy of Suzanne & Edwin Meyer)

A similar box can be found in a large ink box with two boys pulling the wagon. (Group E)

Plate 99

Boy sitting with a large fan-shaped, hollow object with tassels on each side. Number 275 incised on cover. Number 103 impressed on base. (Group C) (Courtesy of Suzanne & Edwin Meyer)

Baskets

Baskets come in several sizes and display flowers, children, animals, or fruit.

Plate 100: **a** **b** **c** **d** **e**
Conta & Boehme

Child sitting inside a two-handled wicker basket holding a horn. Beside her sits a jester doll. This box comes in at least nine sizes. The smallest size is pictured.

a) 7" tall. Number 37 incised on base. IX (size number) in ink on both cover and base. (Group D)

b) 5-1/4" tall. Number 496, IV (size number) and number 24 incised on base. (Group C)

c) 4" tall. Number 496/7 and number 121 incised on base. (Group C)

d) **MATCHBOX**: 3-3/4" tall. Number 1986 and number 37 incised on base. Striking surface on the underside of the cover. (Group C) (Courtesy of Suzanne & Edwin Meyer)

e) 2-1/2" tall. Unmarked. (Group A)

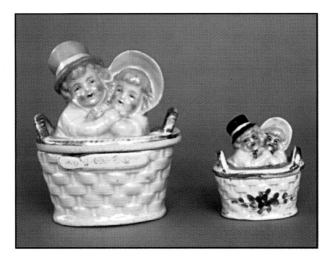

Plate 101: a b Conta & Boehme

a) Boy and girl in an embrace. Conta shield and model number 3617 impressed on cover. (Group B) (See Plate 42.)

b) **MINIATURE:** 2-1/4" tall. Conta shield and model number 73 impressed on cover. (Group A)

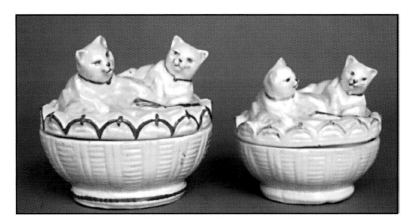

Plate 102: a b Maker unknown

a) Two cats lying on a tasseled pillow. Number 2751 impressed on cover. (Group B) (Possibly Conta & Boehme) (Courtesy of Suzanne & Edwin Meyer)

b) Numbers illegible. (Group B)

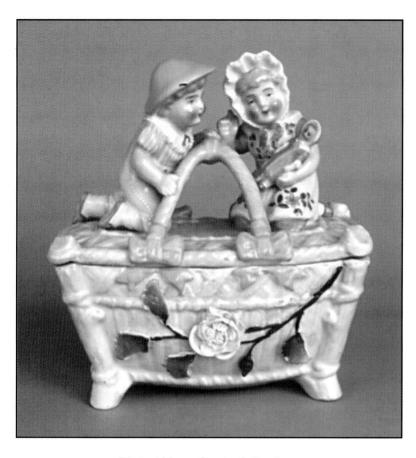

Plate 103: **Conta & Boehme**

Girl and boy kneeling on top of a two-handled picnic basket.
Girl is holding a doll.
Conta shield and model number 3628 impressed on cover.
Large box. (Group E)

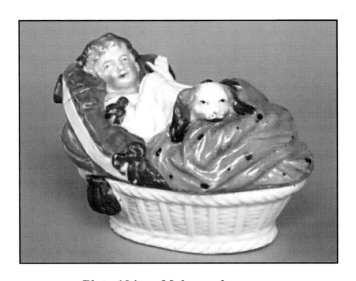

Plate 104: **Maker unknown**

Baby girl and dog. Very colorful and heavy box.
Unmarked. (Group C) (Courtesy of Suzanne & Edwin Meyer)

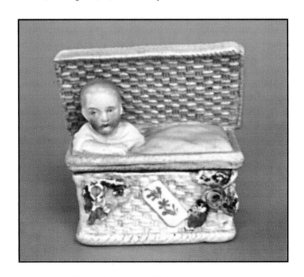

Plate 105: **Maker unknown**

Child peeking out of a wicker basket.
Unglazed. Number 1 impressed on cover. (Group B)

This same box can be found as a fairing box with caption: *Cabin Baggage* and
comes in many size. (Fairing: Group C) (Large box: Group E)

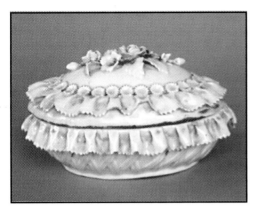

Plate 106: **Conta & Boehme**

Large oval SOAP BOX decorated with flowers and leaves. Rosettes and cloth hanging over the edge in folds. Porcelain liner inside with drain holes. Unmarked. (Group A)

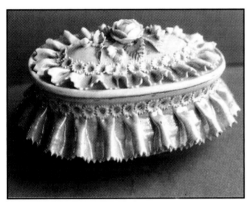

Plate 107: **Conta & Boehme**

TRINKET BOX very similar to the soap box above, but smaller. Unmarked. (Group A) (See Plate 40.) (Courtesy of Hans Walter Enkelmann)

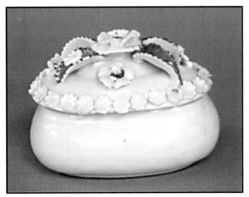

Plate 108: **Maker unknown**

TRINKET BOX decorated with flowers and leaves. Edge trimmed in a different type of rosette. Very plain base. Number 1002 impressed on base. (Group A) (Courtesy of Suzanne & Edwin Meyer)

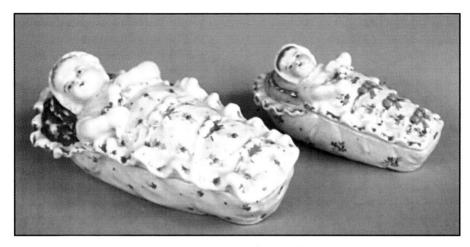

Plate 109: a b Conta & Boehme

a) Infant wrapped in bunting holding a rattle. Three bows decorate the blanket cover. Comes in at least six sizes. 7" long. Unmarked. (Group C) (See Plate 41-a.)

b) 4-3/4" long. Model number 2329 and II (size number) incised on base. (Group B)

Plate 110: a b Maker unknown

a) One fruit resembling a pear or fig, hanging on a stem with two green leaves. Unmarked. (Group A)

b) Basket of assorted fruit. (The base of this box with one vertical warp strand is very similar to Plate 102 which has two vertical warp strands.) (Circa 1870's) Unglazed. (Group A)

93

Chairs and Tables

Plate 111: a b c Maker unknown

a) Woman in white cap and full apron sitting in a pink-cushioned chair holding a coffee grinder. Unmarked. (Group B)

b) Dog sitting in a fancy-backed chair wearing a tasseled tam and smoking a long-handled pipe. Unmarked. (Group B)

c) Ladies side chair decorated in gold rosettes. Removeable seat has a daisy-like flower and four green leaves in center. Unmarked. (Group A)

Plate 112: a b c Conta & Boehme

a) Child in high chair holding a spoon. Conta shield and model number 2196 impressed on cover. (Group B)

b) **MINIATURE:** Child wearing tasseled beanie sitting in a chair reading a book. 2-3/4" tall. Unmarked. Group A)

c) **KATE GREENAWAY:** Three little maids with bonnet and muff. Conta shield only impressed on base. (Group B)

This same box can be found as a matchbox. Striking surfice will be located on a box attached to the back of the chair. (Group B)

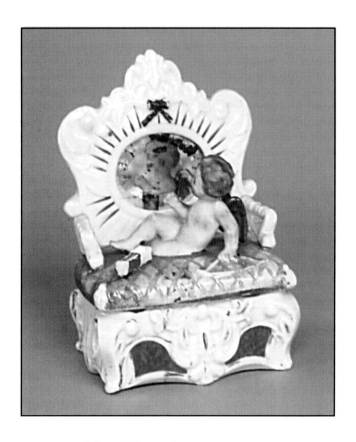

Plate 113: Maker unknown

Large fancy cushioned chair. Cupid with bow and arrow
sitting in chair looking into the mirror. Unmarked. (Group C)

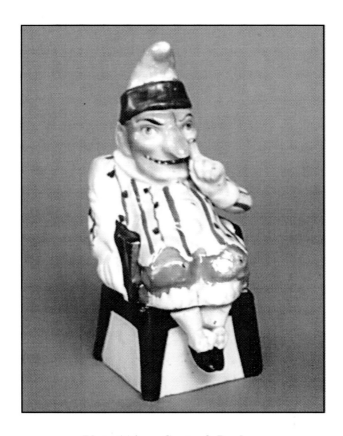

Plate 114: Conta & Boehme

"Punch" sitting in chair with finger placed beside his nose. He may possibly have a mate, "Judy." Unmarked. (Group D) (Pair: Group E) (Courtesy of Suzanne & Edwin Meyer)

Punch (a short, fat, humpbacked clown or buffoon) and Judy are two famous characters in an English puppet show. The show originated in Italy. The name Punch comes from Punchinello.

Plate 115: a b c Conta & Boehme

a) Victorian marble-top table with draping. Teapot, creamer, two cups/saucers, and a serving bowl. Model number 479 and II (size number) raised on base. (Group B)

b) Same as (a) minus the serving bowl. Unmarked. (Group B)

c) **MINIATURE:** Same as (a) with only teapot, creamer, and one cup/saucer. 1-7/8" tall. Model number 23 incised in mirror image on cover. (Group A)

Plate 116: a b c Conta & Boehme

a) Man and lady standing on either side of a book with violin laying on it. Model number 1280 incised on cover. (Group C) (Courtesy of Suzanne & Edwin Meyer)

b) Oval cloth draped table. Pocket watch, book, ring, gun, whip, anchor, and a seal stamp. Model number 494 and II (size number) incised on cover. (Group B)

c) Oval cloth draped table with half-round dome for cover with two fruit. Unmarked. (Group A)

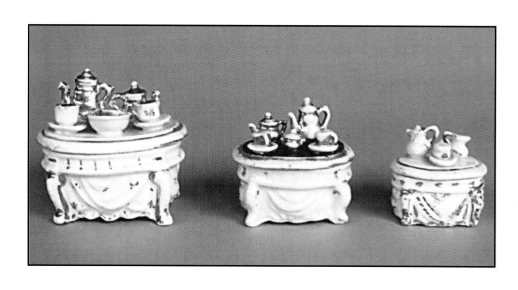

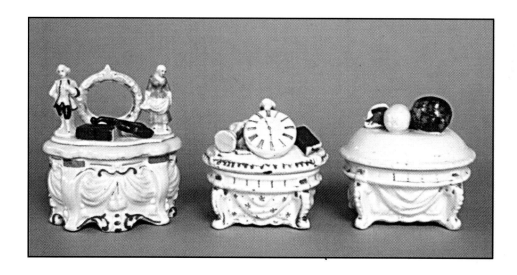

Bureau or Dresser Boxes

(Circa 1850—1891)
(by Conta & Boehme unless noted)

Plate 117: a b c

a) Girl holding her doll by the legs dunking its head in a bowl of water. Conta shield, model number 3595, and number 124 impressed on cover. (Group C)

b) Girl sitting holding a doll to face the mirror. Conta shield, model number 3591, and number 147 impressed on cover. (Group C)

c) Girl sitting with arms around a basket which contains a dog. Conta shield, model number 3589, and number 156 impressed on cover. (Group C)

Plate 118: a b c

a) Boy and cat on seesaw. Unmarked. Mate to (c). (Group C) (Pair: Group D)

b) **KATE GREENAWAY:** Three little maids with bonnet and muff sitting on a log. Conta shield only impressed on cover. (Group C) (PICTURED ON FRONT COVER)

c) Boy and cat have fallen off the seesaw. Conta shield and model number 3636 impressed on cover. Mate to (a). (Group C) (Pair: Group D)

Plate 119: a b c

a) Boy sitting on two German helmets reading a book. Horn on ground beside him. Conta shield, model number 3582, and number 179 impressed on cover. (Group C)

b) Large yellow rose with a green/brown leaf. Conta shield and model number 3610 impressed on cover. (Group B)

c) **KATE GREENAWAY:** Two little girls holding hands, each with a purse. Conta shield and model number 3652 impressed on cover. (Group C)

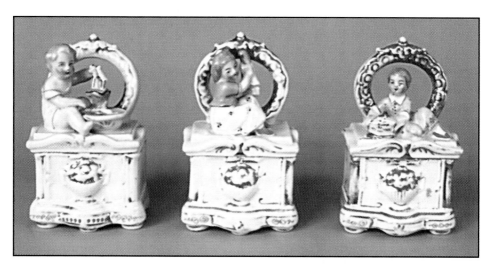

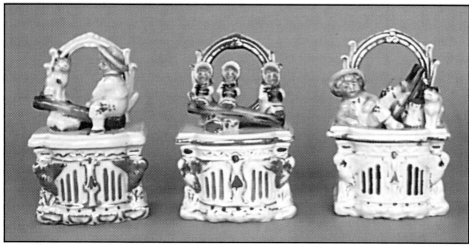

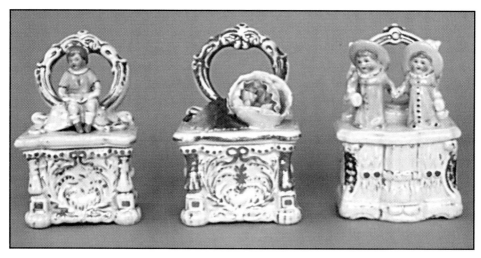

Plate 120: a b c

a) Two cats. One inside a man's boot, the other sitting on a lady's bonnet. Conta shield and model number 3669 impressed on cover. (Group C)

b) Two little girls sitting on a box sipping a cup of tea. Conta shield and model number 3665 impressed on cover. (Group C)

c) Male duck with cane and top hat (missing). Female duck with scarf and shawl. Conta shield and model number 3655 impressed on cover. (Group C)

Plate 121: a b c

a) Boy showing girl his magical skills. He holds an empty black top hat and behind him, a rabbit. Conta shield and model number 3676 impressed on cover. (Group C)

b) Little girl sitting holding a bouquet of flowers in each arm and a letter in her left hand. Conta shield and model number 3663 impressed on cover. (Group C)

c) Girl with dish feeding a chicken. Conta shield and model number 3662 impressed on cover. (Group C)

Plate 122: a b c

a) Two bulldogs each sitting on a cushion reading a newspaper. Conta shield and model number 3681 impressed on cover. (Group C)

b) Girl playing with Jack-in-the-box. Conta shield and model number 3673 impressed on cover. (Group C)

c) Very ornate box composed of twigs and leaves. Bracelet, ring, pin, and cross. Model number 2971 incised on cover, number 168 incised on base. (Group B)

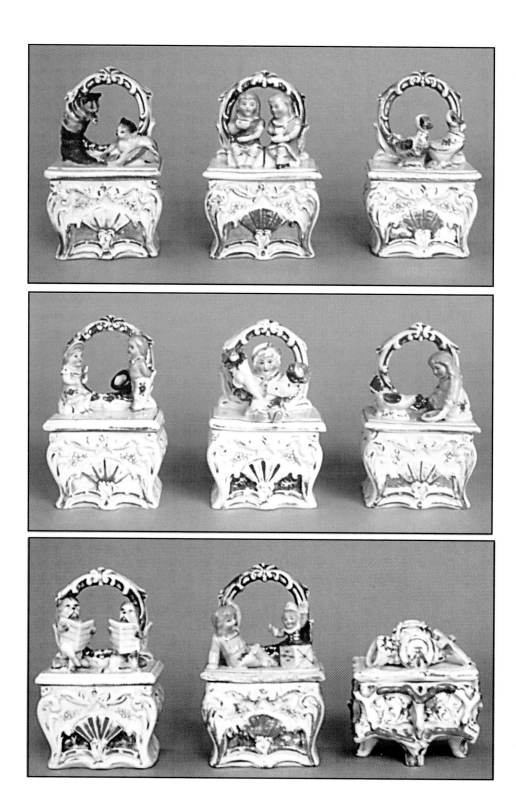

Plate 123: **a b c**

a) Girl kneeling beside a carpetbag holding something in her hand. Conta shield and model number 3600 impressed on cover. (Group C)

b) **KATE GREENAWAY:** Three little maids with bonnet and muff. Conta shield, model number 3618, and number 164 impressed on cover. (Group C)

c) Girl holding a brush sitting beside dog. Conta shield, model number 3598, and number 164 impressed on cover. (Group C)

Plate 124: **a b**

a) **MARBLED BOX**: Victorian sideboard with teapot, creamer, cup/saucer, two goblets and a bottle. These boxes can be found in several sizes and designs including commodes. We have been unable to find any information on marbled boxes. Number 1324 incised on cover. (NOTE: the same number as Plate 124-b.) (Group A) Maker and age unknown.

b) Man with turbin and sword riding a horse. Two flower vases. Number 1324 incised on cover. (Group C) Maker unknown. (Courtesy of Suzanne & Edwin Meyer)

Plate 125: **a b c**

a) Girl pretending to ride a closed umbrella. Conta shield and model number 3608 impressed on cover. (Group C)

b) Boy with pointed cap sitting on a log holding a flag. Conta shield, model number 3609, and number 123 impressed on cover. (Group C) (Courtesy of Suzanne & Edwin Meyer)

c) Large white rose with one green/brown leaf. Conta shield and model number 3613 impressed on cover. (Group B)

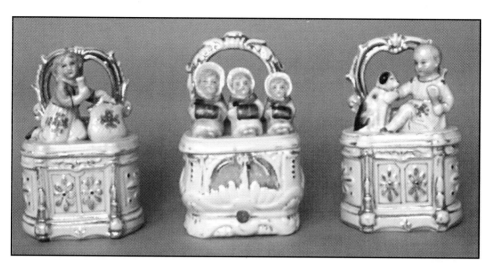

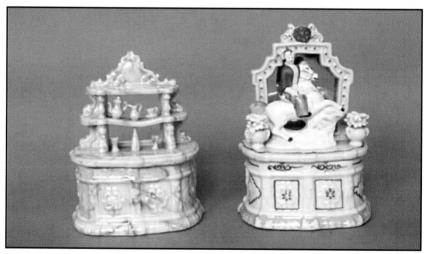

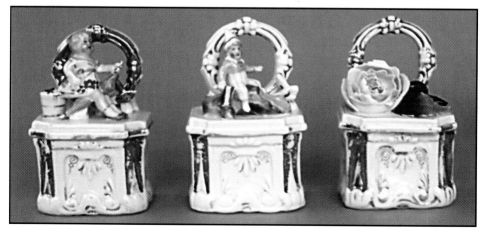

Plate 126: a b c

a) Girl on fireplace mantel looking into the mirror. Cup/saucer and pitcher on mantel beside her. Conta shield and model number 2909 impressed on cover. (Group B) (Set of three: Group C)

The design for this box was probably taken from the English author, Charles Lutwidge (pen name: Lewis Carroll), who wrote the storybook called *Alice Through the Looking Glass.*

b) Same as (a). Unmarked. (Group B)

c) **MINIATURE:** Same as (a), but with a two-handled vase on mantel. 2-3/4" tall. Unmarked. (Group A)

Plate 127: a b

a) Assortment of fruit (pears, plums, and a large cluster of grapes). Model number 3539 incised on cover. (Group B)

b) Basket of assorted fruit. Conta shield and model number 3544 impressed on cover. (Group B) (Courtesy of Suzanne & Edwin Meyer)

Plate 128: a b c

a) One man band. Man in jester's outfit sitting on a drum. He plays the horn and symbols with his hands, beats a drum with his foot. Model number 3505 incised on cover. (Group C)

b) Little Red Riding Hood and The Wolf. Conta shield and model number 3543 impressed on cover. (Group C)

c) A Moor mother (from northwestern Africa) holding her child. Unmarked. (Group C)

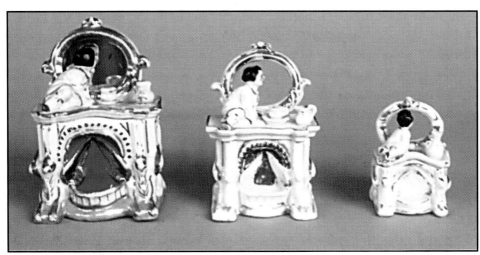

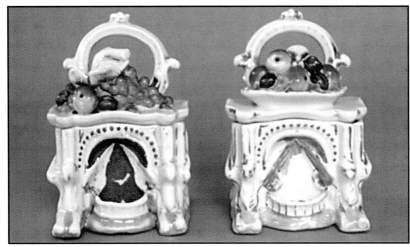

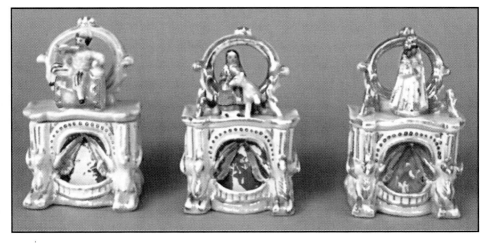

a) Large and small crown, sword, and scepter. Unmarked. (Group B)

b) Table (set with teapot and two cups/saucer) and two chairs. Model number 2904 or 3904 incised on cover. (Group B)

a) Pocket watch, ring, seal stamp, and two covered jars. Model number 2921 incised on cover. (Group B)

b) **MINIATURE:** Same as (a) without the two covered jars. 2" tall. Model number 42 and II (size number) raised on cover. (Group A)

c) Hunters hat, powder flask, rifle, horn, and knife. Deer head with large antlers applied to mirror frame. Model number 2942 incised on cover. (Group B)

a) Lady with paddle rowing a boat. Model number 2990 incised on cover. (Group C)

b) Lamb lying on cushion. Bell around his neck and a gold cross leaning on his body. Model number 2983 incised on cover. (Group C)

c) Dog lying on cushion with front paws crossed. Unmarked. (Group C)

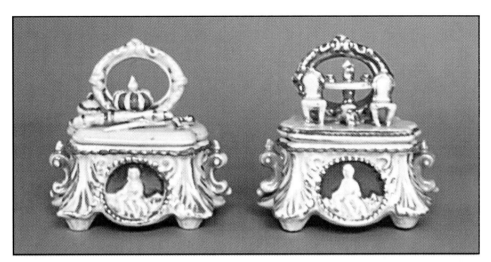

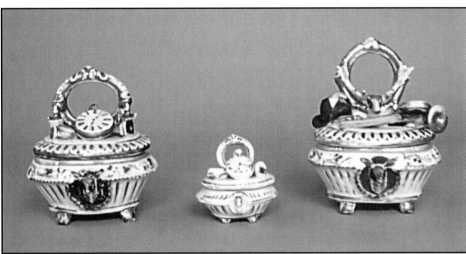

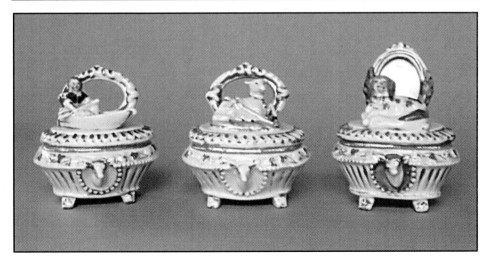

Plate 132: a b c

a) Commode with green ruffled cloth overlapping top. Washbowl and pitcher. Fancy cutout sides and backing decorated with gold painted rosettes. Unmarked. Maker unknown. (Group B)

b) **MINIATURE:** Commode with washbowl, pitcher, and glass. 2-3/8" tall. Model number 29 incised on cover. (See Plate 31-a.) (Group A)

c) Commode with washbowl, pitcher, and two glasses (one missing). Unmarked. Maker unknown. (Group B)

Plate 133: a b c

a) Draped commode with washbowl and pitcher. Glass and cologne bottle on shelf in back. No mirror, solid backing. Model number 1392 incised on cover. Maker unknown. (Group B)

b) **MINIATURE:** Same as (c) but with washbowl only, cologne bottle and cup on shelf in back. Mirrored. 2-3/4" tall. Unmarked. (Group A)

c) Draped commode with washbowl only, glass, cologne bottle, and soap container on shelf in back. Mirrored. Model number 486 and II (size number) incised on cover. (Group B)

Plate 134: a b c

a) Commode with washbowl, pitcher, and two glasses. Chamber pot on bottom shelf. Model number 487 and II (size number) raised on cover. (Group B)

b) Commode with washbowl, pitcher, and two glasses. Chamber pot on bottom shelf. Unmarked. (Group B)

c) Commode with washbowl, pitcher, and two glasses. Chamber pot on bottom shelf. This box is quite heavy and larger than (a) and (b). Unmarked. Maker unknown. (Group B)

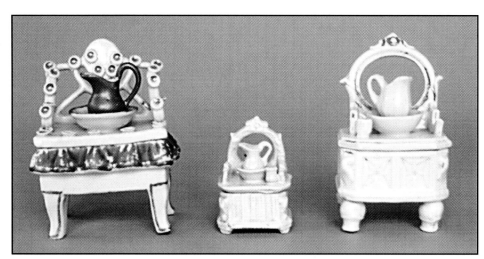

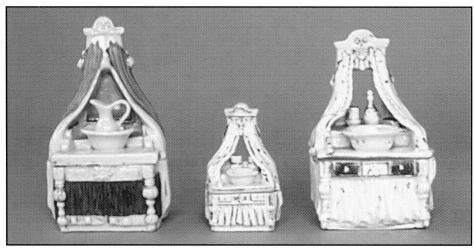

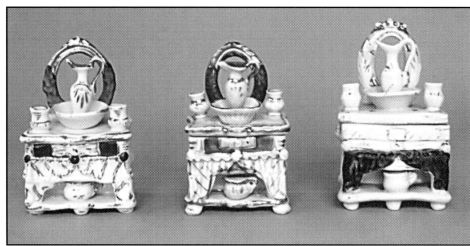

Plate 135: a b c

a) Commode with recessed basin holding a Victorian style pitcher. Unmarked. (Group B)

b) Lady standing in front of vanity primping her hair. Jewelry box with open cover, powder box, and a perfume bottle on vanity top. Model number 2939 and II (size number) incised on base. (Group B)

c) Slant-top desk with two drawers on each side of the mirror. Ink and sander on desk top with book. Model number 2112 incised on base. (Group C)

Plate 136: a b c

a) **MINIATURE:** Cabinet with book shelves on each side filled with books, two vases and a clock in the center. 2" tall. Model number 24 raised on the cover. (See Plate 31-b.) (Group A)

b) Dresser with shelves on each side of mirror. Teapot, creamer, cup and saucer. Model number 2902 incised on cover. (Group B)

c) **MINIATURE:** An old woodburning stove with shelves on the back. 1-1/2" tall. Model number 62 incised on cover. (See Plate 31-c.) (Group A)

Plate 137: a b c

a) Piano with three music books and a bouquet of flowers. Model number 472 and I (size number) incised on cover. (Group B)

b) **MINIATURE:** Piano, same as (a) but with different mirror frame. 2" tall. Model number 22 incised on cover. (Group A)

c) Six compartment jewelry box with open cover. Fancy key lock on the front center of base. Unmarked. Maker unknown. (Group A)

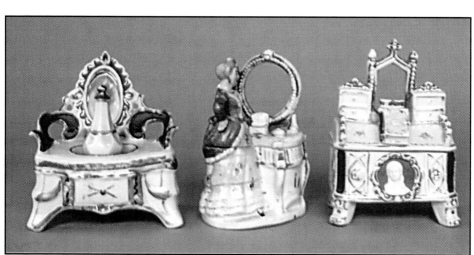

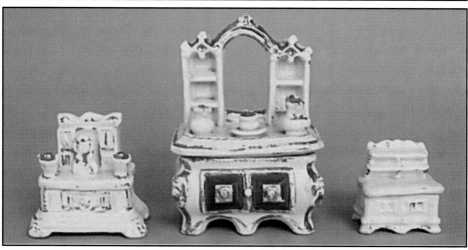

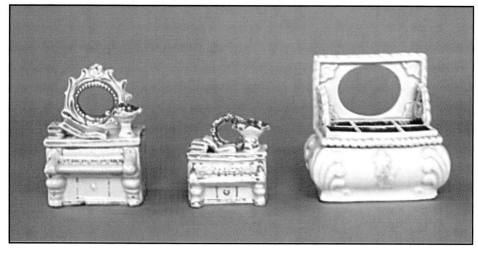

Plate 138: a b

a) Vanity with two small covered jars and a two-handled vase in the center. Model number 1415 impressed on cover. Maker unknown. (Group B)

b) Vanity with sea serpent side rails, a soap dish in center and a combination candelabra/flower vase on each side. The base has deer antlers in the center with a mythical creature at each corner. Unmarked. (Group B)

Plate 139: a b

a) Dresser with swivel mirror frame and clock. Three circles inside of mirror frame. Unmarked. (Group A)

b) Dresser with swivel mirror frame. It appears to have a cover which pulls down from the mirror. The edge of the cover is decorated with round, raised half-circles. Base resembles a basket pattern. Unmarked. (See Plate 24-b.) (Group A)

Plate 140: a b Maker unknown

a) Large dresser with cloth hanging in folds around the edge of the cover along with gold painted rosettes. Mirror not as fancy as (b). Top contains two vases with a clock in the center. 6-3/4" tall. Unmarked. (Group B)

b) Large fancy dresser with cloth hanging in folds around the edge of the cover along with gold rosettes. The mirror is decorated with fruit and flowers. A fancy, empty basket sits on top. 6-3/4" tall. Unmarked. (Group B)

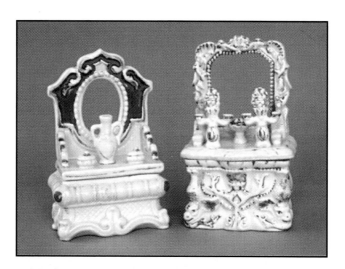

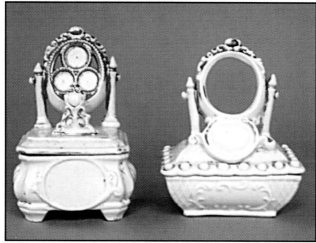

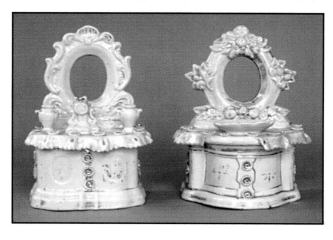

Plate 141: a b c

a) Boy sitting on box holding a cup and spoon. Dog standing on hind legs with front paws on boy's shoulders. Conta shield, model number 3577, the letter **P**, and number 94 impressed on cover. (Group C)

b) Dog licking boy's face. Ball and stick beside them. Model number 3569 and the letter **P** impressed on cover. (Group C)

c) Monkey playing the drums. Horn beside him. Model number 3570 and the letter **P** impressed on cover. (Group C) (Courtesy of Suzanne & Edwin Meyer)

Plate 142: a b c

a) Angel hatching from an egg. The angel's little fanny is showing through a crack in the shell. Conta shield, model number 3573, the letter **P**, and number 112 impressed on cover. (Group C)

b) Mother cat and kitten playing with a ball. Conta shield, model number 3579, and number 113 impressed on cover. (Group C)

c) Two kittens playing with a ball of yarn. Yarn basket tipped over. Model number 3564 incised on cover. (Group C)

Plate 143: a b c

a) Girl holding ball. Spectacles on her forehead. Conta shield, model number 3575, and number 165 impressed on cover. (Group C)

b) Girl reading book while dog sits beside her. Conta shield, model number 3560, the letter **P**, and number 134 impressed on cover. (Group C)

c) A Turk sitting on a pillow reading a paper. Water pipe beside him. Conta shield, model number 3562, and number 491 impressed on cover. (Group C)

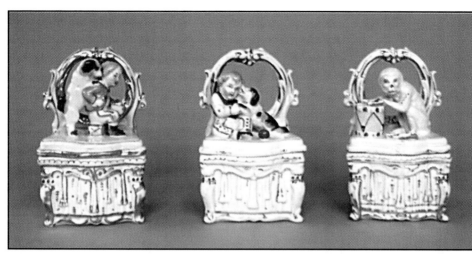

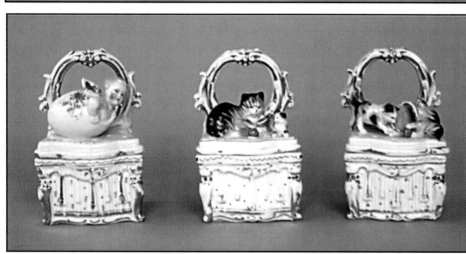

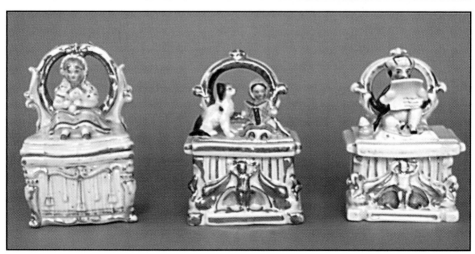

Plate 144: a b c

a) Large and small crown, sword, and scepter. Model number 2903 incised on cover. (Group B)

b) Boy with stick holding onto a large dog. Model number 2999 incised on cover. (Group C)

c) Boy sitting watching two birds in a bird bath. Unmarked. Maker unknown. (This box is either a Conta & Boehme box or a copycat. The box is heavier, all the details on the base and lid are larger, and the mirror frame has straighter angles.) (Group C) (Courtesy of Suzanne & Edwin Meyer)

Plate 145: a b c

a) Large white rose with one green leaf. Conta shield and model number 3611 impressed on cover. (Group B)

b) Same as (c) except it does not have the two covered jars and is a smaller size. Unmarked. (Group B)

c) Pocket watch, ring, seal stamp, and two covered jars. Model number 2904 raised on cover. (See Plate 23-a.) (Group B)

Plate 146: a b c

a) Angel sitting on a gold crucifix. Conta shield and model number 3531 impressed on cover. (Group C)

b) **MINIATURE:** Cat playing with a brown mouse. Fence on left. 2-1/4" tall. Unmarked. (Group A) (Courtesy of Suzanne & Edwin Meyer)

This very same box can be found with the cat playing with a green frog. Conta shield, number 50, and number 38 impressed on cover. (Group A)

c) Carrier pigeon with letter around his neck. Model number 3518 incised on cover. (Group B)

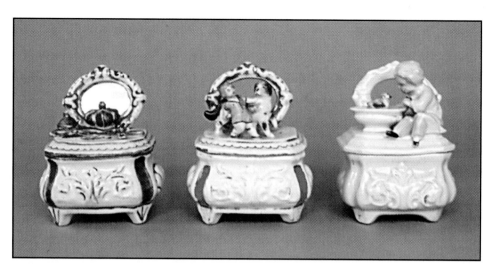

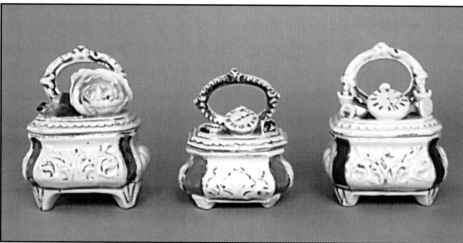

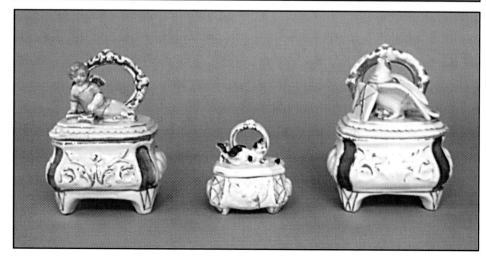

Plate 147: a b c

a) Boy in canopied bed putting on his trousers. Raised Conta shield, model number 3576, and number 154 impressed on base. Mate to (c). (Group C) (Pair: Group E)

b) Baby lying in cradle with cat curled up at its feet. Conta shield and model number 3566 impressed on cover. (Group C) (Courtesy of Suzanne & Edwin Meyer)

c) Girl in canopied bed putting on her stockings. Raised Conta shield, model number 3572, and number 110 impressed on base. Mate to (a). (Group C) (Pair: Group E)

Plate 148: a b c

a) Two large buildings (one with steeple) connected in front by a high wall, in back by a smaller building. Behind sits a tall tower. (Buildings unknown.) Model number 2949 incised on cover. (Group B)

b) Dog lying on a cushion with paws crossed. Model number 2934 incised on cover. (Group C)

c) Emperor Wilhelm I. Model number 2954 incised on cover. (Missing cross on top of crown.) (Group C)

Plate 149: a b c

a) Paddlewheel steamer. Model number 2955 incised on cover. (Group B)

b) Man and lady on seesaw. Model number 2988 incised on cover. (Group C)

c) Coil of rope, anchor, weight, and a compass. Model number 2968 incised on cover. (Group B)

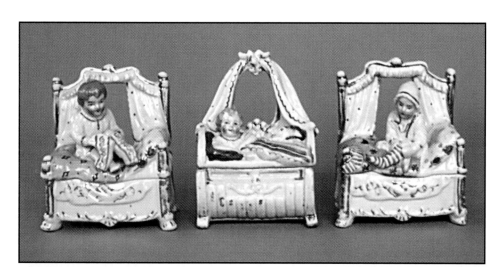

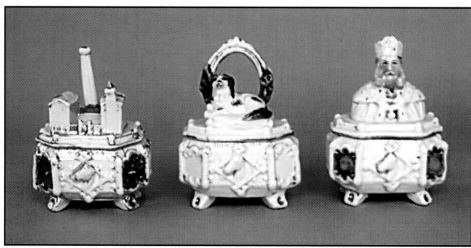

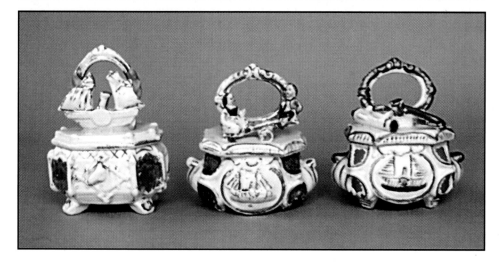

Plate 150: a b Maker unknown

a) Cutout altar with Bible in center. Angel kneeling on the center of the base. Model number 2981 incised on base. (Group B)

b) Altar with red painted heart lying on an open Bible. Anchor leaning against the heart. Heavy box. Unmarked. (Group B)

Plate 151: a b Conta & Boehme

a) Altar with crucifix, Bible, chalice, and holy water pitcher. Angel in center of base. Conta shield, model number 3523, and number 157 impressed on cover. (Group C)

b) Altar with crucifix, Bible, chalice, and holy water pitcher. Number 484 or 489 and II (size number) incised on cover. (Group C) (Courtesy of Carl Cotton)

c) **MINIATURE:** Same as (b). 2-1/2" tall. Model number 25 incised on cover. (Group A)

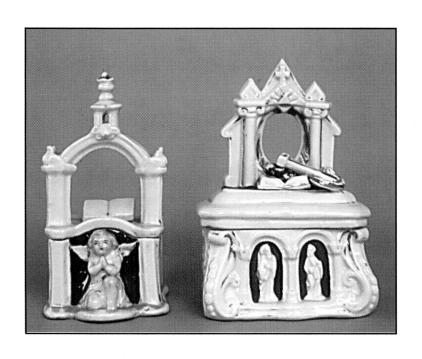

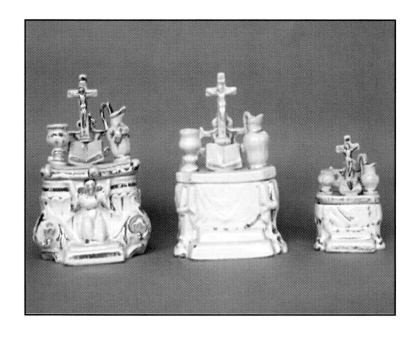

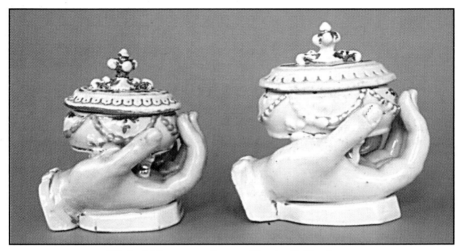

Plate 152: a b Conta & Boehme

a) Ladies **RIGHT** hand holding a box with cover. Conta shield, model number 490, number 61, and II (size number) impressed on cover. (Group C)

b) Same as (a). Model number 490 incised on base. (Group C)

NOTE: The handle on the cover will always consist of five small round balls originally painted in gold.

Plate 153: Conta & Boehme

Ladies **LEFT** hand holding a box with cover. Model number 2950, number 158, and II (size number) incised on base. (Group D)

(NOTE: Left hands are RARE.)

Miscellaneous Boxes

Plate 154:
Conta & Boehme

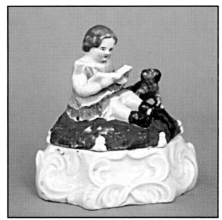

Plate 155:
Conta & Boehme

Young girl nestling a mother hen and four baby chicks. Placement of chicks may vary on each box. Model number 2926 incised on base. (Group B)

Girl sitting on cushion reading a book. Dog at her side. Unmarked. (Group B)

Plate 156: a b Maker Unknown
Typical Seaside Resort Boxes

a) Decorated with morning glories and vines. Unmarked. (Group A)

b) The base consists of seashells. The top is decorated with morning glories and other flowers found along the seashore. Model number 1280 incised on cover. (Group A)

Plate 157: a b c

a) German helmet, bugle, sword, and artillery shell. Unmarked. Conta & Boehme. (Group A)

b) Coffin-type box with large bow and tassels on cover. Mirror frame has a crown and two crossed flags on top. Unmarked. Maker unknown. (Group A)

c) Box draped in cloth with ruffles and tassels. Tasseled pillows on either side of the shield-shaped mirror frame. Unmarked. Maker unknown. (Group A)

Plate 158: a b c Maker unknown

a) Large brown trunk draped with a blanket. On top sits a child with rabbit inside a man's large shoe. A heavy box. Unmarked. (Group B) (Courtesy of Suzanne & Edwin Meyer)

a) Girl with watering pail sitting among flowers. Model number 2511 and number 39 incised on cover. (Group A) (Courtesy of Suzanne & Edwin Meyer)

c) Cupid lying on grass with a dove perched on his arm. Bow and arrow on grass in front of him. Unmarked. (Group A)

Plate 159: a b c Maker unknown

b) French bisque. Girl lying on grass-covered rabbit's den with two rabbits peeking out through hole. 12 gold eggs on grass beside her. Very light in weight. Unmarked. (Group B)

b) Man dressed in colonial fashion sitting on a grass covered mound. Long hair tied back with a bow George Washington style. Unglazed. (Mate: Lady on same base.) Unmarked. (Group A) (Pair: Group B)

c) Maiden. Unglazed. (Mate: Cavalier). Unmarked. (Group A) (Pair: Group B)

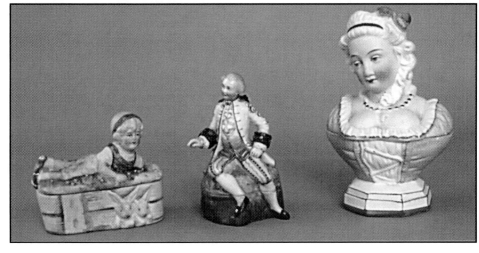

German Jasper Ware

(Maker unknown)

Mention Jasper Ware and the first thought that enters most people's mind is the Wedgwood factory. Joseph Wedgwood was the originator of Wedgwood, Queen's Ware, and Jasper Ware. His Jasper Ware was made with figures in relief, or with a raised design, and adorned many objects made from jasper. White cameo reliefs on a blue background proved to be the favorite, so much so, that many German firms began copying it in the late-nineteenth century. However, the quality has never been reproduced.

We have titled these boxes German Jasper Ware only to fit them into a category. They do not; however, represent Wedgwood's Jasper Ware in any way.

The design on the covers of these boxes has been carved in relief. They all have a blue background and all picture an angel or cupid. Boxes in Plate 160-c and 161-a may have the bird and the arm applied to the relief.

Plate 160: a b c (Group B)

a) Mother and child angel. Oval, 3" long. Model number 1617 incised on cover. (Courtesy of Suzanne & Edwin Meyer)

b) Cupid. Oval, 4" long. Model number 1545 incised on cover. (Courtesy of Suzanne & Edwin Meyer)

c) Angel and dove. Oval, 4-1/4" long. Model number 1546 incised on cover. (Courtesy of Suzanne & Edwin Meyer)

Plate 161: a b (Group B)

a) Angel and dove. Octagon, 4-3/4" long. Model number 716 incised on base. (Courtesy of Suzanne & Edwin Meyer)

b) Madonna and Child. Oval, 4-1/4" long. Lion's head on each end of the base. Model number 1558 incised on cover.

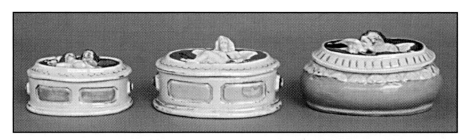

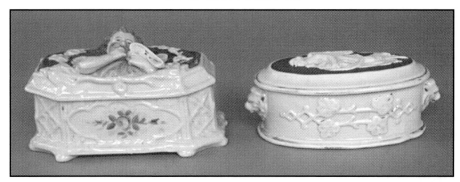

Plate 160: a b c

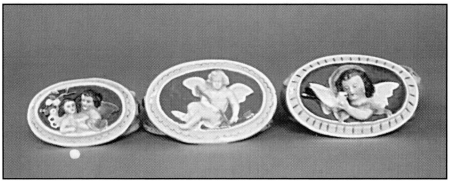

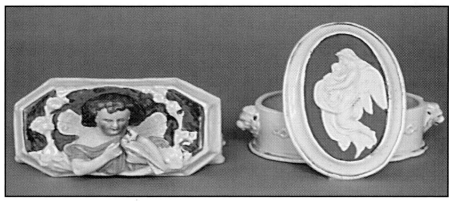

Plate 161: a b

Matchboxes

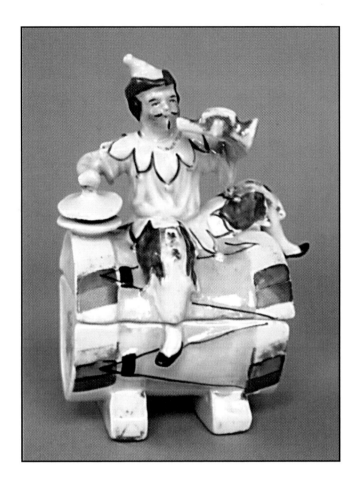

Plate 162: Conta & Boehme

One Man Band: Man dressed in a jester's outfit playing the horn and symbols with his hands, and beats the drum with his left foot. 4" tall. Striking surface on underside of the cover. Number 114 incised on base. (Group D) (Courtesy of Suzanne & Edwin Meyer)

This same "One Man Band" can also be found in a large trinket box approximately 10" tall, plus several smaller sizes. He plays the same instruments as the matchbox above with one more addition, he also rings bells with his right foot. A dog sits between his legs. Conta shield and model number 2564 impressed on cover. (Large box: Group E)

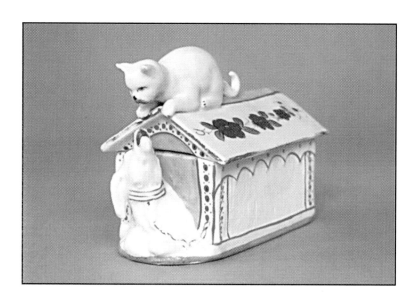

Plate 163: **Conta & Boehme**

Cat sitting on top of dog house teasing the dog. Striking surface on the side of the dog house. Conta shield, model number 993, and number 117 impressed on base. (Group C) (Courtesy of Suzanne & Edwin Meyer)

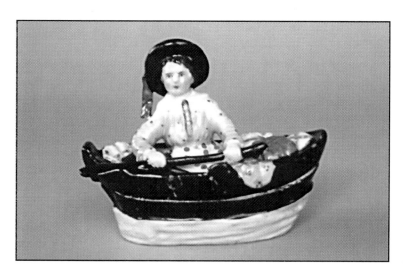

Plate 164: **Conta & Boehme**

Man in rowboat with fancy gift-wrapped packages beside him. Unmarked. (Group B) (Courtesy of Suzanne & Edwin Meyer)

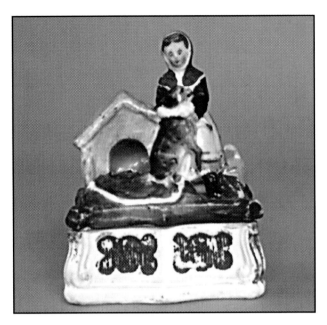

Plate 165: Maker unknown

Girl standing beside dog house embracing her dog. Handled basket and umbrella on the ground. Striking surface under the cover. Unmarked. (Group C) (Courtesy of Suzanne & Edwin Meyer)

Plate 166: Maker unknown

An interesting matchbox embossed "Pins." Striking surface on underside of the cover. Unmarked. (Group B) (Courtesy of Suzanne & Edwin Meyer)

Plate 167: Conta & Boehme

KATE GREENAWAY: "Tom, The Piper's Son" lying on the cover of a very plain matchbox. Striking surface on underside of the cover. Conta shield and model number 7100 impressed on base. (Group B) (MATE: Girl lying on cover. Same model number.) (Pair: Group C)

This same matchbox can be found without any decorative item on the top. (Group A) It can also be found with a molded design on the cover as pictured below.

Plate 168
Conta & Boehme

This matchbox was sold at the 1876 Centennial Exhibition in Philadelphia, Pa. The Centennial Exposition was to celebrate the hundredth anniversary of the signing of the Declaration of Independence. It was the first successful world's fair in America. One of its buildings has been preserved as the Pennsylvania Museum of Art. The molded design shows Machinery Hall and the word *Centennial*. (Group D)

Plate 169

The Conta carriage
house connected to
the factory building.

During a remodeling project of the porcelain factory in 1988, workmen pulled up the floor boards between the first and second story. Found beneath the boards were porcelain pieces of all sorts. To discard this rubbish in the easiest manner, they removed a window from the second story and tossed everything out the window, landing in a pile on the ground.

During our visit to Possneck, Hans Walter Enkelmann took us to visit the Conta & Boehme factory. We were given permission to dig in the pile and found many broken pieces, nothing whole.

Plate 170

The carriage house,
factory building, and
the rubbish pile tossed
out the window
above.

Plate 171

Thomas Enkelmann, Hans Walter's son, searching for buried treasure.

Bibliography

History of Conta & Boehme
and
The Porcelain Mark

1. *"Thuringer Porcelain"* by Helmut Scherf, VEB Seemann, Book and art publisher, Leipzig, 1980, page 340, 344, 345

2. Possneck city archives, B I 16 f number 5, page 6-7

3. above, page 33-40

4. *"100 Year Possneck Newspaper,"* 1928, Gerold Verlag (publisher) Possneck, page 27

4. Siebmachers *"Large & General Coat of Arms Book,"* Nuemburg, 1954

5. *"Possneck Porcelain,"* unpublished works of H. W. Enkelmann

6. Discussions with Possneck's elderly residents

7. Engravings from the tombstones of the Upper Cemetery in Possneck

8. Church books of the Possneck City Church. (From the Baptist Register and the Death register)

9. The World Book Encyclopedia, copyright 1949

10. Webster's Ninth New Collegiate Dictionary